SS NORMANDIE

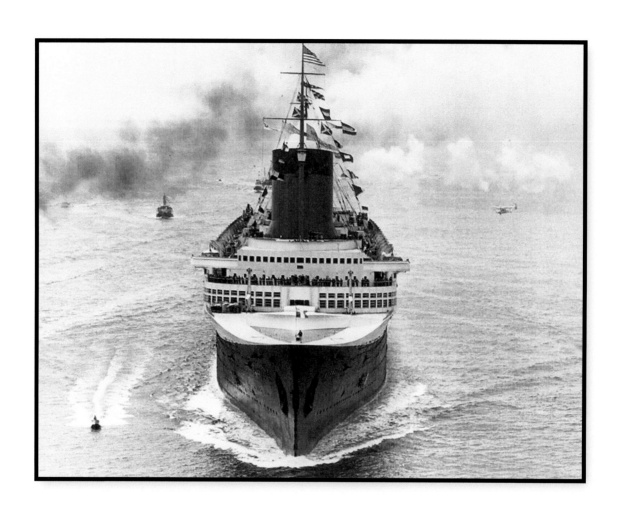

SS NORMANDIE

WILLIAM H. MILLER

The History Press

Dedication

To Mario Pulice
who has been a dear friend, a most generous contributor and who has added
greatly to ocean liner history with his extraordinary collection.

Acknowledgements

Mario Pulice; Der Scutt; Mary Pelzer and Carol Rauscher; Tom Cassidy; Richard
Faber; and the staff at South Street Seaport Museum.

Additional thanks to Bill Deibert, the late John Gillespie, Lewis Gordon, the
late John Havers, Pine Hodges, the late Thomas Hoving, Martha Levin, John
Maxtone-Graham, the late Vincent Messina, Richard Morse, Maria Riva, Mary
Louise Schaff, the late James Sesta, the late Arthur Taylor, Frank Trumbour, Jack
Watson and Steven Winograd.

First published 2013
Reprinted 2022

The History Press
97 St George's Place,
Cheltenham, Gloucestershire, GL50 3QB
www.thehistorypress.co.uk

British Library Cataloguing in Publication Data.
A catalogue record for this book is available from the British Library.

ISBN 978 0 7524 8808 0

Typesetting and origination by The History Press
Printed by TJ Books Limited, Padstow, Cornwall

Frontispiece: Normandie arriving in New York Harbor
for the first time. (South Street Seaport Museum)

MIX
Paper from
responsible sources
FSC
www.fsc.org FSC® C013056

CONTENTS

FOREWORD

Seventy-eight years ago this May (2013), the *Normandie* set sail on her first voyage. Built during the Great Depression, she was in every sense of the phrase 'a stimulus package'. Costing $364 million (accounting for inflation), she was heavily subsidised by the French government, who poured money into the construction of an icon. In New York, too, her grand arrival was greatly anticipated when the city began its construction of a Hudson River pier to accommodate CGT's latest floating sensation. Mayor Fiorello La Guardia noted: 'While the *Normandie* was being built in France, we, here, were building a huge pier, probably the largest in the world, to accommodate her. It is my sincere hope that we have done as well in providing a proper setting for the world's largest ship as you have done in building it.'

Luxurious, sensuous and sophisticated, she stimulated the senses, creating an unparalleled atmosphere of chic whose beauty is no less legendary than Helen of Troy. Even though she sailed for little more than four years, ocean liner and art historians continue to laud the vessel's style. Modern ship designers still emulate her features and aficionados covet her stylised furniture.

Her demise was as terrifying as her birth glorious and voyages decadent. Catching fire, smoke could be seen from the skyscrapers rising from Manhattan's schist. Reporters, noticing the plumes, flocked to the scene with wartime paranoia well at hand. Their reports incited an animated curiosity that roused 30,000 onlookers to visit the site the very next day.

Our show, *DecoDence*, opened in January 2010 and, running for fourteen months, was a tribute to the grandeur, glory and sheer excitement of the *Normandie*. Special thanks once again go to the exhibit's curator, Bill Miller, 'Mr Ocean Liner' himself, and this book which follows in the wake of *DecoDence*.

So once again, welcome aboard the *Normandie*!

Mary Ellen Pelzer
Past President
South Street Seaport Museum

INTRODUCTION

The 1,028ft-long *Normandie* was not only the largest and most powerful in a long list of great French ocean liners, but she was also by far the most luxurious and innovative. Externally, she was one of the best-looking liners ever created – she was streamlined, raked and rounded, and capped by three plump funnels done in the Compagnie Generale Transatlantique's (CGT) red and black. Advanced in design, she was one of the most modern-looking ocean greyhounds of her day. Within, she was lavishly bestowed with the finest French decorative touches – Aubusson carpets, Dupas glass panels and Lalique 'towers of light'. Her first-class restaurant was done in bronze and hammered glass, was illuminated by great chandeliers (again by Lalique) and sat 1,000 guests at 400 tables. The wines were included in the fare, the service impeccable and the food, of course, was the finest at sea. 'You can never, ever diet on the French Line,' a company brochure aptly pointed out. Everything about the *Normandie* was totally and purposefully French, down to the packets of matches in the bars and the notepaper and envelopes in the writing room.

With her construction beginning in 1931, at St Nazaire on the Loire, the 30-knot, quadruple-screw *Normandie* was to be the French rival to the greatest, grandest and fastest Atlantic super liners of the Depression-era 1930s. Germany had *Bremen* and *Europa*, Italy had *Rex* and *Conte di Savoia*, and Britain was planning two mega-ship record breakers, the first of which, *Queen Mary*, was due a year later in the spring of 1936. The French were firm on completing *Normandie* a year or so before *Queen Mary* with the aim of not only capturing the prized Blue Riband, but garnering the greatest publicity and public attention. Quite simply, it was all about national rivalries. The French wanted to beat the British.

These days, *Normandie* often fills my thoughts. Of course, I am reminded of her in new books, magazine articles, a freshly made television documentary. But I also still use the Manhattan piers, arriving and sailing aboard contemporary cruise ships. These ships – white, sparkling, and often larger and taller than *Normandie* –

sometimes use Pier 88. It is rebuilt now, but it was the long-ago home of the French Line and was where *Normandie* berthed, then burned and of course capsized. There is a bronze plaque in the pier's second-floor waiting room commemorating the brave salvage crews that partially dismantled and then righted the stricken liner. I rarely fail to notice it. Also, over on the western side of the Hudson, I often drive along the New Jersey Turnpike. Not far from Manhattan, it skirts along the western edge of Port Newark, these days a busy marine freight complex. I often briefly peer out to the last piece of dock and again there is a reminder of *Normandie*. Her scarred, ruined hull was scrapped there some sixty-five years ago. And yes, I sometimes see the bronze doors at Our Lady of Lebanon in Brooklyn Heights and, of course, attend ocean liner bazaars and auctions that usually feature some item from *Normandie*.

She is still a great ship, a ship very much in my thoughts and, I suspect, in the minds and hearts of many others. I certainly agree – there was no ship quite like her!

Bill Miller
Secaucus, New Jersey

GRAND PREDECESSORS

The first French-owned and -operated transatlantic steamer service began in 1847, seven years after Britain's Cunard Line and eight before Germany's Hamburg America Line. But this French operation soon failed. A second attempt was made in 1855 as the Compagnie Generale Maritime, organised by two enterprising brothers, Emile and Isaac Pereire, with a base capital of 1 million francs. They were certainly earnest in their quest – within a year, the new company had no less than seventy-six ships sailing to ports around the world. But expectedly, the North Atlantic service from Le Havre as well as Bordeaux to New York was the most prestigious, most demanding, and the most competitive. Within two years, and with the backing of the Rothschild family, five new steamers for the New York run (and another seven for service to the West Indies) were ordered. Lucrative mail subsidies were soon guaranteed by the French government. By 1861, with further government financial assistance, the firm was renamed Compagnie Generale Transatlantique, quickly known as CGT.

But new tonnage, such as the 3,400grt Washington, had to be built abroad, at Greenock in Scotland. France did not yet have the expertise or facilities to construct such large ocean-going vessels. So, again with further backing from the French government, CGT bought a strip of land at the mouth of the Loire, in an area known as Penhoet, and with considerable assistance from the Scots began to build a shipyard of their own. The first new build was the Atlantique, renamed Imperatrice Eugenie by the time she was launched in April 1864.

CGT prospered, even if they relied mostly on first- and second-class passengers rather than the infamous, but very lucrative, steerage as well as mail. In 1876 the company advertised the first use of an on-board 'lighthouse' (warning lights) and then 'potent fog horns'. That same year, Amerique was the first electrically lighted steamer on the Atlantic. By 1891, with good times continuing, the company introduced the 9,047-ton La Touraine, then the fifth largest passenger ship in the world and one of the fastest (19 knots). She was also noted for her grand interiors and superb cooking, images that CGT soon recognised as their most positive image. Decor and food would be the hallmarks of CGT liners from then on. And, of course, there were the important elements of reliability and continuity. By 1895, CGT offered a sailing from Le Havre to New York, and vice versa, every Saturday throughout the year.

By 1900, CGT had added the likes of the 11,100-ton sisters La Lorraine and La Savoie to their fleet, followed by the 13,700-ton La Provence in 1905, which had a rather exceptional 23-knot top speed. The Le Havre–New York passage was cut to six days. Success and progress prevailed at the company's headquarters and by 1910 an exceptional ship was in the works. To be called La Picardie, she would weigh in at 23,600 tons and

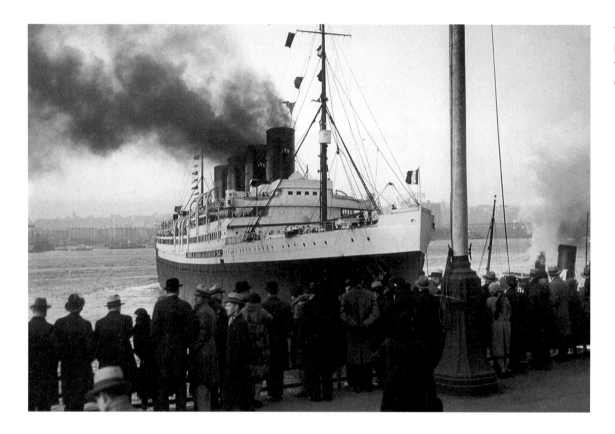

The *France*, the only four-stacker in the French fleet, is seen departing from New York's Pier 59 in 1925. (Cronican-Arroyo Collection)

be capped by four funnels – then the ultimate mark of transatlantic might, power and sea-going security. She was, in fact, the culmination of CGT's first fifty years and, of course, a great national symbol. When she went down the ways at St Nazaire on a summer's day in 1910, by which time her name had been changed to *France*, she was introducing a fleet of some of the most spectacular liners ever created.

While the 713ft-long *France* was by no means the longest or fastest liner of her day, she was one of the most luxurious. She lured the very top end of trans-ocean society. This was coupled with the much-envied French Line service and superb cooking. Dubbed the Chateau of the Atlantic, the long, low, almost racy-looking *France* was a favourite for years to come.

Although interrupted by the First World War, the French government – as the major investor in the CGT – wanted more great liners. National prestige was extremely important; the 'glory of France' had to be rightfully and proudly represented on the most prominent ocean liner runs in the world. The French wanted to join the likes of Britain and Germany in that elite club of passenger liner supremacy. Paris ministers were generous

– there were increased mail subsidies, liberal construction loans and a firm contract that called for new liners, perhaps even a new ship every four years.

In the wake of the great success of *France*, the 34,500grt *Paris*, whose construction was begun in 1913, to be completed in 1916 but then halted because of the war, finally emerged in the summer of 1921. She was pleasing in almost every way, especially due to her stunning decor. Her first-class accommodations were so popular that she had the lowest number of vacant berths in first class of any Atlantic liner during the mid-1920s.

The 764ft-long *Paris* differed from the heavily gilded stylings of *France*, but instead introduced a new, more contemporary look: Art Nouveau. Some say that she was the beginning of genuine ocean liner style; others attribute this to the next French liner, the deco-styled *Île de France*, which appeared six years later. *Paris* broke from the trend of copying shore-side structures, such as manor houses and country homes, chalets and hunting lodges, and instead used a decorative style more of her own. She was a

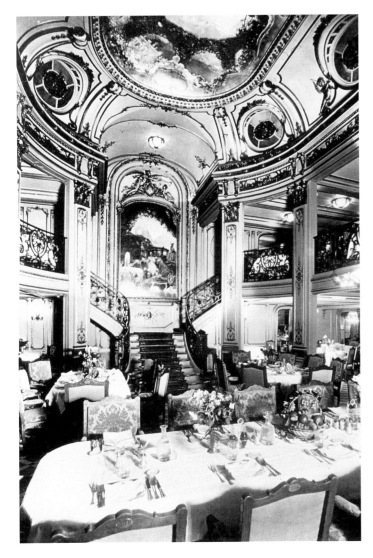

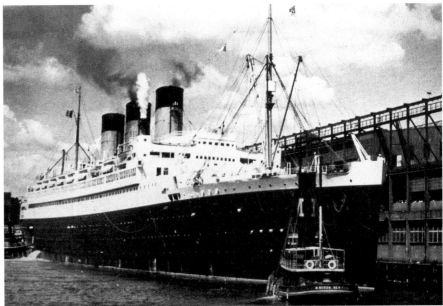

Above: With whistles blasting, the popular *Paris* departs from Pier 88, New York, in this scene from 1936. (James Sesta Collection)

Above: The stunning first-class dining room – with the grand stairway as an entrance – aboard *France*. (Author's Collection)

Right: The outbound *Paris* seen from the upper decks of the inbound *Île de France*. (Author's Collection)

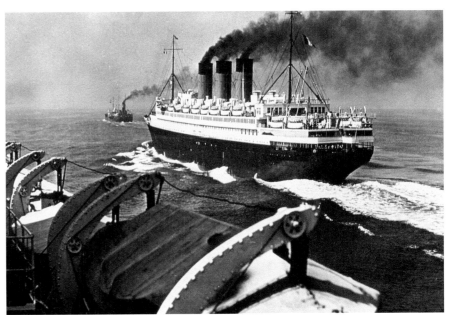

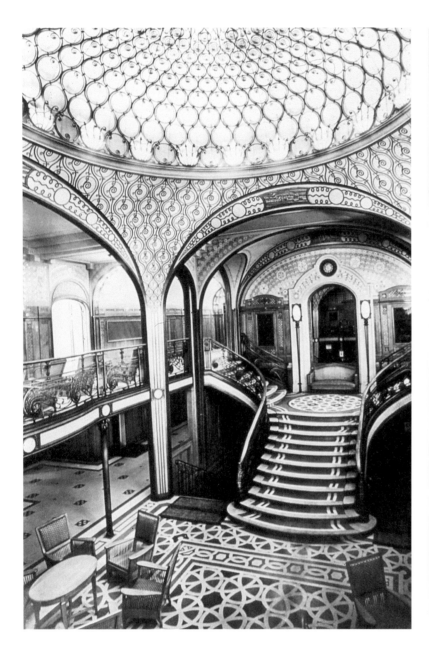

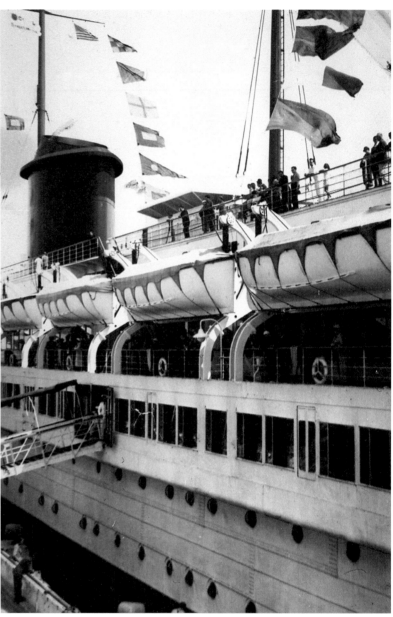

The first-class foyer aboard the *Paris*. (Author's Collection)

Dressed in flags, *Champlain* prepares to set off from Le Havre on her maiden crossing to New York, in June 1932. (Cronican-Arroyo Collection)

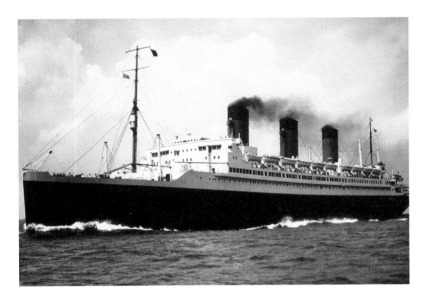

On the outside, the stunning *Île de France* of 1927 was a larger, modified version of the earlier *Paris* of 1921. (Author's Collection)

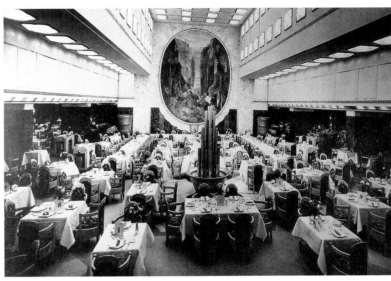

Compared to a modern-day Greek temple, the first-class main restaurant aboard *Île de France* was an extraordinary space. Again, a grand stairway served as an entrance. (Author's Collection)

sensation! But after a serious dockside fire at Le Havre in August 1929, *Paris* was repaired and at the same time modernised. Much of the Art Nouveau came out and was replaced by the even more modern, *Île*-inspired Art Deco. She was more popular than ever and, of course, now an even better match to the slightly larger but immensely popular *Île de France*.

While moderate liners seemed to be more in vogue in the 1920s and better suited to the accountants' needs, the French opted next for a larger, grander, more sumptuous version of *Paris*. The 43,000-ton *Île de France* was commissioned in 1927 – a three-stacker that immediately captured the imagination not only of the travelling public, but the world. Innovative, trendsetting, luxurious and, with the finest kitchens afloat, she was in many ways the most successful, most beloved of all French liners.

The accommodation aboard the 791ft-long *Île de France* was divided into three classes: first class, cabin class and third class. But all cabins, even in lower-deck third class, had beds instead of bunks. Her first-class quarters were exceptionally lavish and included a large assortment of *suites de luxe*. It was said to be the finest selection of suites on the Atlantic. By 1935, *Île de France* had carried more first-class passengers than any other transatlantic liner.

But it was her overall style, her extraordinary decorative tone that fascinated the travellers, the general public, as well as other shipping lines – competitors to CGT, or the French Line as it was commonly called in America. Copied from the influential *Exposition des Arts Décoratifs*, held in Paris in 1925, the *Île's* interiors were the beginning of Art Deco on the high seas. It was the immediate new standard of ocean liner decor and style, and was soon transferred to the likes of office buildings, hotels, railway terminals, even theatres and department stores. Almost singlehandedly she introduced the sleek new age of angular furniture, sweeping columns and panels, inventive lighting and a great sense of spaciousness that all but eliminated the heavy and high clutter of prior liners. The first-class bar was said to be the largest afloat and the main restaurant, likened to a Greek temple, rose three decks in height. Typically, it had a grand staircase as a main entrance, another feature that became a CGT trademark. The main foyer was also three decks high and the chapel was done in Gothic with fourteen pillars. In every way a 'floating city', the 1,786-passenger *Île* also had a shooting gallery, merry-go-round and a fully equipped gymnasium.

The late Lewis Gordon, a veteran of over 100 Atlantic crossings, recalled:

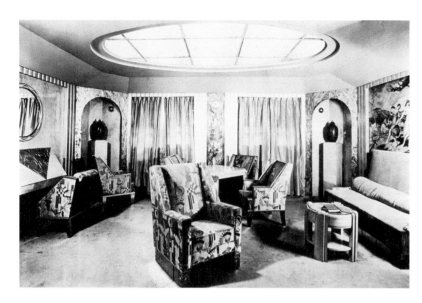

Art Deco in high form: the sitting room of a suite aboard *Île de France*. It was ground-breaking, innovative decor for the 1920s. (Author's Collection)

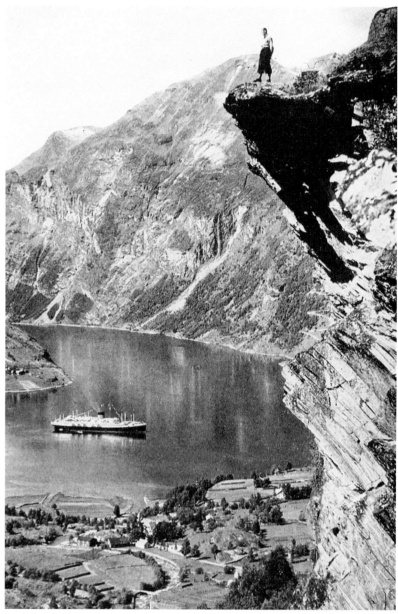

Cruising to the Norwegian fjords: *Lafayette* of 1930 is visiting on a cruise from Le Havre. (Author's Collection)

From the beginning of her days, the *Île* always had a great reputation. She was said to be the happiest and cheeriest way to cross the Atlantic. And, of course, she had great glamour. More celebrities – royalty, politicians and especially Hollywood stars – preferred her. The *Île* always, always had a distinct tone of chic, that very special French chic, about her!

While CGT built the likes of the 17,000-ton *De Grasse* in 1924 and the 13,300-ton *Colombie* in 1931 for services to the French colonial Caribbean islands, major thinking was still focused on the North Atlantic. The 25,000-ton *Lafayette* joined the New York service in 1930, followed by the 28,000grt *Champlain* two years later. This pair was dubbed 'cabin liners' since the equivalent of first class aboard them was renamed as cabin class. It was generally a sales technique, offering slightly lower rates in the more frugal 1930s. After all, overall Atlantic passenger traffic had dropped from 1 million in 1930 to 500,000 by 1935. The more smartly decorated of the pair and the more modern looking, the 1,053-passenger *Champlain*, was said to be the great prelude to a 'super ship' that the French were planning for the mid-1930s. Meanwhile, other French

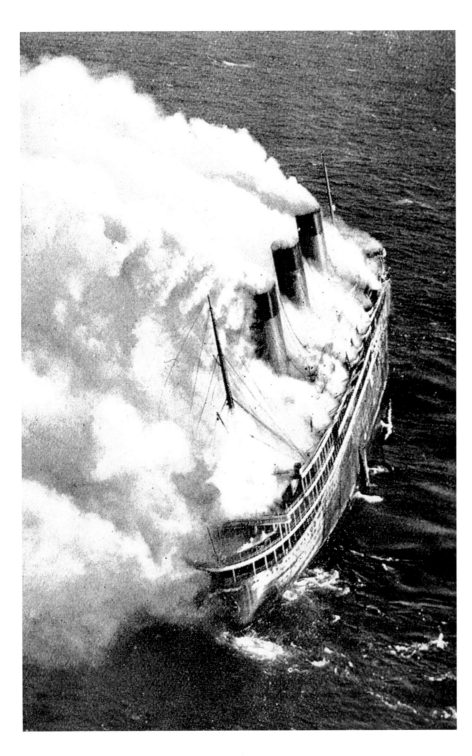

Tragedy at sea: fire destroys the otherwise brilliant
L'Atlantique in 1931. (Author's Collection)

passenger lines, namely Messageries Maritimes and Compagnie Navigation Sud-Atlantique, also produced important and often noteworthy passenger ships, but for routes away from the North Atlantic. Most notable was the 42,000grt *L'Atlantique*, a grand three-stacker created for the Bordeaux–East Coast of South America run in 1931. Like *Île de France* before her, she was a tour de force of Art Deco innards and another prelude to CGT's exceptional super liner.

If the French had any doubts about creating a large, very fast super liner, they were spurred on by the thought of national prestige. The grand race was on! Around them, the Germans were creating a pair of 50,000-tonners, *Bremen* and *Europa*; the Italians had the impressive *Rex* and *Conte di Savoia* on the drawing boards; while across the Channel, White Star was planning the 60,000grt *Oceanic* and Cunard had an even bigger super ship in mind. There was little doubt – the French had to move forward. The first keel plates were laid down in January 1931 at the much-expanded Chantiers de l'Atlantique yard at St Nazaire for the biggest, fastest and grandest French liner to date. The government underwrote shipyard expansion. The first plans showed a 60,000-tonner of 960ft in length. But upon hearing of White Star's 1,000ft-long *Oceanic*, ideas changed quickly. The French flagship absolutely had to be bigger still.

FABULOUS LINES & QUINTESSENTIAL GLAMOUR

'I think that the *Normandie* was the most magnificent of the great liners,' said Frank Trumbour, a world-class ocean liner collector and former president of the Ocean Liner Museum in New York City. 'Her fabulous lines and that quintessential interior combined to make her the most glamorous of all the great liners. She is a great favorite and, I know, a great favorite to many others. And she and her legend live on.'

In his fine book, *Lives of the Liners*, the late Frank Braynard wrote: 'Few ships have impressed themselves so indelibly upon the common consciousness of our age as the great French liner *Normandie*. She so attracted the enthusiastic interest in the world that the extent of her influence on ship design, travel tastes, style, the movies and even toys is impossible to measure.'

Beginning in the winter of 1930, just months after the devastating Wall Street Crash, the shipping world was stoked to excitement by the details of the 'super *Île de France*', a huge, fast, luxurious liner. Everything was in place. The actual construction order was signed on 29 October 1930; the shipyard at St Nazaire was busily preparing and expanding for her construction. Apart from her vast proportions, most exciting to many was the fact that she would be driven by turbo-electric engines, a type of propulsion machinery unheard of in a vessel of her size. Beginning in 1928, more medium-sized liners like P&O's *Viceroy of India* used

The Art Deco age reached beyond the liners to shore – to the great skyscrapers of Manhattan. (Author's Collection)

turbo-electric, as did three new American liners, *California*, *Pennsylvania* and *Virginia*. It had further appeal and success in the early 1930s: P&O used it with the sisters *Strathnaver* and *Strathaird*; Furness Withy with *Monarch of Bermuda* and *Queen of Bermuda*; Ward Line with *Morro Castle* and *Oriente*; and the Dollar Line with *President Coolidge* and *President Hoover*. Additionally, press releases for the new French flagship were seasoned with rumours: it was said she would exceed 60,000 tons and would be the first ship of any kind to exceed 1,000ft in length. She would cost an estimated 700 million francs. One comparison was especially exciting – the 20,000-ton ark built by Noah in the Bible was only a third of the size of the future liner. For the more sophisticated New Yorkers, it was reported that if standing on her stern, she would be more than 200ft higher than the famed Woolworth Building. The rudder would fill Washington Square Arch and the ship itself would be too broad to fit into Fifth Avenue. The public was almost dizzy with fascination and interest.

In October 1931, after construction had long begun and as many as 1,500 workmen applied their skills each day, it was revealed that the French flagship would have three funnels, each of decreasing height. She was known only by a builder's number, T6. During 1932 it was said by 'those in the know' that she would be named *President Doumer*, in honour of the recently assassinated president of France. Then days before launching, on 29 October, it was officially revealed that the name *Normandie* had been selected. *President Doumer* had been abandoned at the request of the martyred president's wife. Eagerly, the public awaited each news release.

It was an age of style, innovation, reaching for tomorrow and the future. Here, famed photographer Margaret Bourke White plies her craft from a Deco gargoyle atop New York City's Chrysler Building. (Author's Collection)

THE FINEST AMBASSADOR

The 82,799grt *Normandie*'s purpose was threefold: to be the world's largest liner (in fact, the first to exceed 1,000ft in length and the first over 60,000 tons); to be the fastest on the Atlantic (although the French never publicly acknowledged this goal since, should she fail for some reason, the publicity damage could be all but devastating); and to be a dazzling, floating testament to all that was French – art, decoration, technology. The French government subsidised much of her construction cost. She would, after all, be the nation's finest ambassador – glittering, exceptionally advanced, the greatest liner of the 1930s, perhaps the grandest passenger ship ever.

Normandie came about in the high spirits of the 1930s, which, although a decade of Depression and the emergence of fascism, with the rise to power of such leaders as Hitler and Mussolini, was the age of superlatives. Sleek, powerful trains reduced distances with their high speeds. Hollywood produced lavish musicals with expansive sets. In New York City, the Chrysler Building soared to 1,046ft (only 18ft more than *Normandie*), but was soon surpassed by the 1,250ft Empire State Building. It was an age where, amongst other things, bigger was better. Even *Normandie*'s crew, 1,339 in all, was the largest then to put to sea – 14 officers, 105 deckhands, 184 engine room staff and 986 stewards. She had 1,100 telephones and enough ovens in her kitchens to roast 768 chickens at

one time. There were also said to be around 275 different items on her first-class dinner menus. *Normandie* was a centrepiece of those times and rarely does a recollection of the '30s exist that does not mention her. Even BBC Television, in a documentary made almost seventy years ago, claimed: 'Art Deco reached its peak when *Normandie* first took to the seas.'

According to Bill Deibert, a marine architect and ocean liner enthusiast:

The *Normandie* was extraordinary in almost all ways. Mechanically, she was one of the first and only super liners to break with convention and incorporate turbo-electric drive to her steam turbine machinery. This was very radical for that time. Externally, her decks were swept clean of clutter … especially when compared to her immediate rival, Cunard's *Queen Mary*. The *Normandie* had no unsightly intake vents which wasted valuable exterior deck space. These were integrated instead into the base of her stacks or vented along the sides of her expansive Promenade Deck. All the machinery for cranes and capstans and winches were carefully incorporated on the deck below, out of sight and out of the passengers' way. Thus, there was an immense sense of streamlining and clean looks. The *Normandie* was also built almost without sheer, allowing her decks to be almost straight. Her graceful appearance was in fact partly created by her exterior paint scheme. Even in smaller,

lesser details, she was refined, clean and advanced. There were no rat lines on the *Normandie*, for example. The *Queen Mary* carried this over out of tradition, but which of course gave her a dated look. In fact, the *Normandie* had no main foremast, but instead two small, forward cargo cranes.

Her designer, Vladimir Yourkevitch, who was actually Russian rather than French, sought perfection and more. Born in Moscow, he later moved to St Petersburg, trained at the Naval Architecture School and later drafted warships – cruisers, destroyers and submarines – for the Imperial Russian Navy. He designed a new, revolutionary hull form that, while graceful looking, increased speed performance so important for warships. Four battleships were ordered and under construction with unique Yourkevitch-designed hulls, but were never completed owing to the First World War and then the Russian Revolution. Yourkevitch himself fled in 1917 during the Revolution and later arrived in Paris by way of Istanbul. He joined Renault, labouring in an automobile factory, but soon found he much preferred ships and ship design. He heard of the new super liner being planned and sent in his designs for a raked, fast-moving ship. His designs and ideas were said to be for the first truly 'streamlined' ocean liner. It was a glorious blending of beauty and function.

He joined Chantiers de Penhoet, the shipyard at St Nazaire, in 1928. Within a year, the genius designer was creating plans for a French 'super

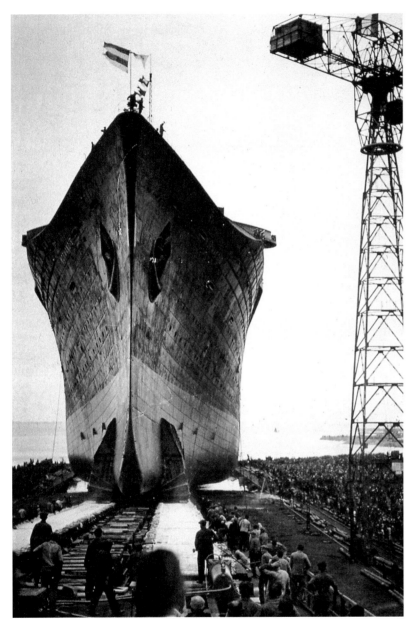

Above: The beginning of her waterborne career: *Normandie* goes down the ways at St Nazaire in October 1932. (French Line)

Right: One hundred workmen were swept into the Loire when *Normandie* was launched. (French Line)

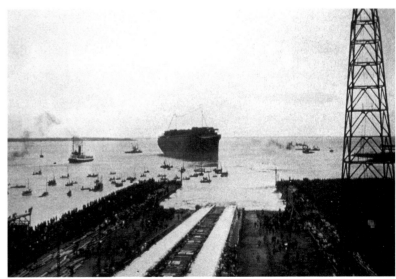

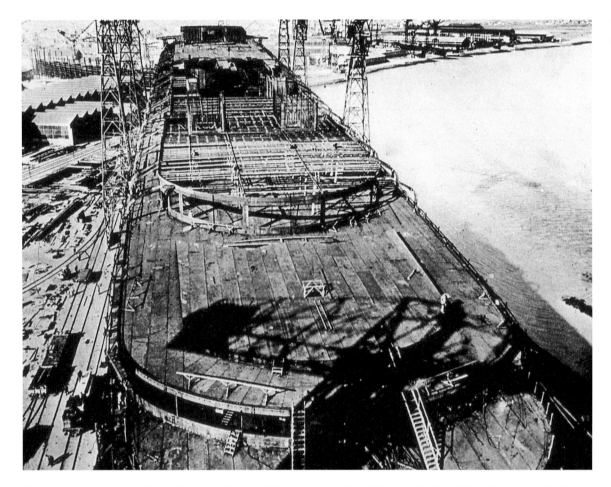

The fitting-out of *Normandie* in 1933.
(French Line)

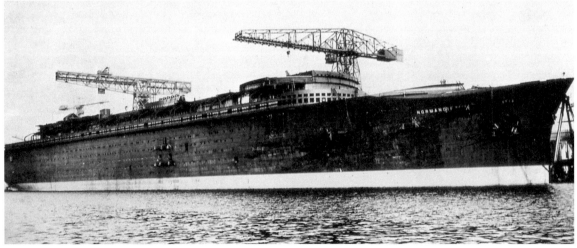

The upper decks begin to take shape.
(French Line)

Further progress: the cranes hover over the 1,028ft-long hull like surgeons attending to a patient. (French Line)

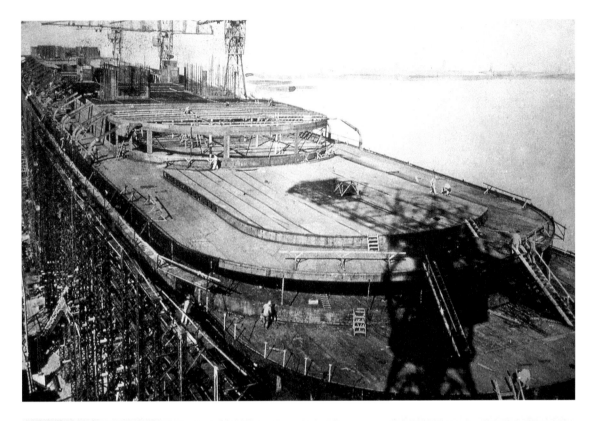

The first and second funnels begin to be assembled – the liner slowly takes her advanced, innovative exterior form. (French Line)

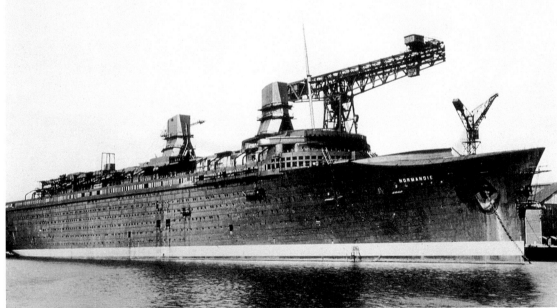

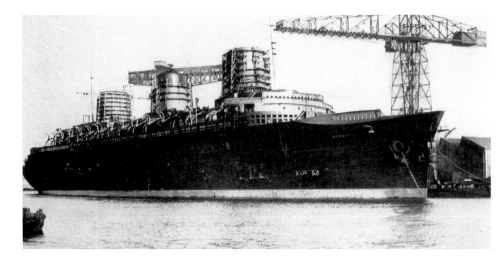

Left: The three mighty funnels became a great symbol of the new flagship of the French Line. (French Line)

Below left: The forward mast awaits positioning. (Cronican-Arroyo Collection)

decks descending in six tiers to a distinctive, eye-catching spoon-like stern. Shipyard managers were more than impressed, especially with the new ship's flared profile, its proportions and its wide, uncluttered decks. The director of the shipyard was sceptical at first, but later allowed some initial tests. Yourkevitch travelled to Hamburg where he tested a 28ft-long paraffin model of his new liner. He discovered errors and even flaws, made corrections and modifications, and returned to France with the results. He was promptly given the green light. In all, it took three years to complete the designs of the entire ship.

Yourkevitch was aboard *Normandie* for her record-breaking maiden voyage in May 1935, but stood on a secluded, upper deck during the arrival into New York Harbor. He later said he was too shy to be among the cheering passengers. His life soon changed, once again. He left France and moved to the United States in 1937 and became a citizen in 1941, residing just outside Manhattan in Yonkers.

Yourkevitch had taken some design elements from *France, Paris, Île de France, L'Atlantique, Champlain* and other Atlantic liners. As construction began, in 1931, more and more evocative and alluring details were released to an increasingly fascinated and aroused public. The CGT's Paris offices were all but overwhelmed with suggestions for a name: from *La Belle France* (a strong contender, it has often been said) to *President Paul Doumer*, the recently assassinated president of France. Even *Jeanne D'Arc, Maurice Chevalier* and *General Pershing* were said to be among the considerations. In his fine book, *Normandie: Liner of Legend*, author Clive Harvey claims that other names were also put forward: *Napoleon, Charlemagne, La Marseillaise, La Paix, La Patrie, Victoire* and some obvious political choices like *Clemenceau, Maréchal Joffre, General Foch* and *Petain*. But the French Line decided that French provinces would be

ship', the vessel that would become *Normandie*. Furthermore, for better use of on-board, lower-deck space, machinery for traditional steam turbines was put aside in favour of almost unheard-of turbo-electric drive. This in itself was a bold decision. But this added to the innovative, forward-looking tone of the new liner. She would have three funnels of descending height, largely hidden deck equipment and obstructions, a raked bow and after

the naming sequence and so *Normandie* was selected. At the same time, beginning in December 1930, work had begun at Clydebank in Scotland on Cunard's new super liner, the pride of Great Britain. While she, too, was still unnamed, something of a more serious race between France and Britain began.

Ocean liner historian Pine Hodges noted:

The incomparable *Normandie* had an outstanding exterior appearance, largely due to her finely shaped, hydrodynamic hull, and a long, high superstructure which extended nearly three-quarters of her total length. Her semi-circular bridge-front and whaleback foredeck served not only to dispel the effects of white water, but greatly emphasised her quintessential 'ocean liner appearance' … Her hull did not contain any flat surfaces, had a fine entry at the waterline, and there was a bulbous forefoot which minimised hydrostatic turbulence. This finely shaped bow permitted the *Normandie* roughly the same speed capability at two-thirds the fuel consumption of her Cunard rival *Queen Mary*. A slightly 'exaggerated' tumble-home amidships gave the *Normandie* a close-to-ideal meta-centric height for stormy Atlantic conditions.

According to liner historian John Maxtone-Graham, she was known as a 'stiff, snappy roller' which 'sprung' quickly back upright following any kind of roll; this efficiency in righting herself often resulted in much broken china, overturned vases and spilled drinks. The ship's three teardrop-shaped funnels descended in height as they progressed aft, to help in dispersing the stack gases; they were given a sloping 'plinth' at their bases to allow for the divided uptakes within.

It took 43 tons of suet, 2½ tons of lard and 1 ton of soap to grease the launching ways at St Nazaire for *Normandie*. Madame Lebrun, the first lady of France, ceremoniously

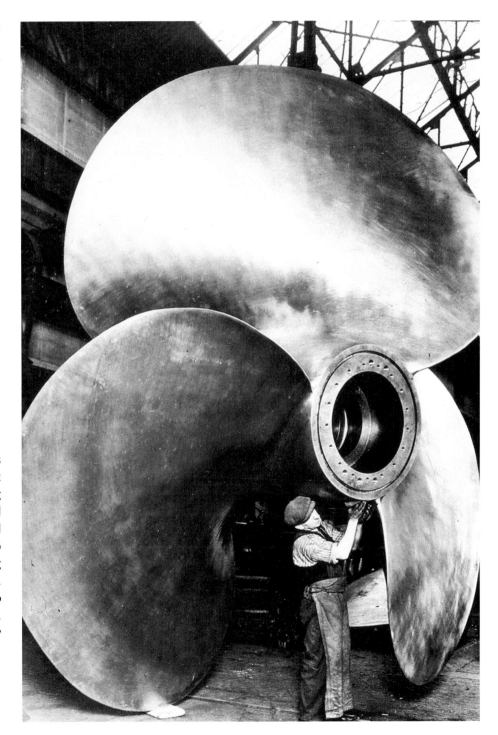

Propellers are prepared for installation. (Cronican-Arroyo Collection)

named the quadruple-screw ship as *Normandie* during the launch on 29 October 1932. She used the world's largest bottle of champagne, six quarts in all. Days before, the scaffolding surrounding the giant ship had been removed and her vast hull stood regally supported by 153 oak blocks, 22 supporting sand blocks and 58 smaller sand blocks. Aptly, the ship was dubbed a 'floating cathedral'. Just prior to launching, with three priests in attendance, the ship was blessed. The unfinished 28,000-ton hull slipped into the Loire, taking with her a quartet of 25-ton drag chains with such a great backwash that it swept 100 workers and visitors into the water. Already, the ship had a sense of the dramatic. She was fully waterborne in seven seconds.

Due out in 1933, the Depression and the worrisome economic climate, to say nothing of declining figures on the Atlantic, caused a delay. 'The ship of the future designed in the present' had to wait. Marcel Oliver, chairman of the French Line, announced in April 1933 that the maiden voyage would be delayed until the spring of 1935. The severe effects of the worldwide Depression had finally reached France, the French Line and, increasingly so, the Atlantic liner trade. Business was already down by almost 50 per cent from 1930. Just as with the new Cunard flagship, construction on *Normandie* was halted for a time. She did not leave the fitting-out dock at St Nazaire until March 1935, almost two years behind the original schedule.

At the same time, something of a dark cloud hung over the French passenger fleet. There were devastating blows: the luxurious *L'Atlantique* had burnt out in 1931; as had the brand-new *Georges Philippar* in 1933. Clearly, French marine fire safety was paramount and so *Normandie*'s advanced and expansive fire proofing was highly publicised. Her French builders and owners were prompt to reveal that the new liner would have over 1,000 heat detectors, 224 fire alarm sirens and 504 fire hydrants on board. They remained extremely positive and reassuring: *Normandie* was said to be the safest ship afloat.

In further preparation, a passenger terminal, with the great size of *Normandie* in mind, was constructed at Le Havre. Adjoining was a new railway terminal – a reinforced concrete structure – to cater for trains to and from Paris. The complex had the look of a pavilion, like the deco at the World's Fair.

In the final months of construction and outfitting, in the winter of 1935, some 6,000 workers were involved directly in the completion of *Normandie*. She began her trials on 5 May and reached Le Havre for the first time on the 11th. But there were some serious worries. Disruptive vibration plagued the aft end of the ship and teams of workers had to be brought in especially to reduce it, as well as reinforce other parts of the vessel. Then there was a last-minute strike by crew members, which might have delayed the ship and embarrassed the French. Sensibly, it was settled quickly. Finally, there had been hushed instances of industrial sabotage and, worse still, political protest. Small fires had broken out at the shipyard, followed by a blaze deliberately started in a stateroom while at Le Havre. In consequence, security was tightened around the flag-bedecked liner.

President and Madame Lebrun hosted a grand, pre-maiden voyage party for 2,000 guests on board. Sir Percy Bates, chairman of Cunard-White Star, was among those included. Vladimir Yourkevitch was not. Having a Russian émigré design the hull of France's finest and grandest liner was clearly not in the nationalist thinking. In fact, he was not even mentioned in the maiden voyage press releases. Discreetly, however, he was given a ticket for the round-trip maiden crossing.

In her final days at Le Havre, another gala party was interrupted by a total, sudden power outage, just as small armies of workers continued to make final adjustments and fittings. In the end, there were 1,276 passengers and 1,335 crew, plus huge quantities of mail, on board for the maiden crossing to New York. Both *Île de France* and *Paris* were in port alongside at Le Havre, sounding their whistles as a send-off to their 'big sister'.

FANFARE & FESTIVITY

The date 3 June 1935 was unquestionably one of New York Harbor's greatest days. Tugs, ferries, excursion steamers, yachts and sprouting fireboats were out and about in full force. Adding to the occasion, special charter aircraft flew overhead, a blimp or two glided over and there was even a giant recreation of Mickey Mouse posed on a special barge. John Maxtone-Graham reminds us: 'The port was black with people. The shorelines, piers and waterfront buildings were crammed with spectators.' Some 30,000 people lined the Battery Park seawall in Lower Manhattan. Flags waved, horns tooted, sirens screeched, and the crowds cheered and applauded. In the midst of the sombre Depression, 'the *Normandie* was a ray of sunlight coming all the way from France', said one writer. The stunning $60 million ship was gleaming in fresh paint, capped by those three enormous red and black funnels and flying a long pennant that identified her as the new Blue Riband champion. On her maiden crossing from Le Havre and Southampton she had surpassed the record of the Italian *Rex*. Her officers, crew and passengers were beaming, and the guest list was topped by none other than Madame Lebrun, the first lady of France and godmother of the ship. After a joyous, well-photographed procession along New York's Upper Bay and then along the Hudson River, the majestic *Normandie* was berthed on the north side of the nearly complete Pier 88, a terminal built especially for her. After an extended stay at that West 48th Street pier, the first rounds of guests, visitors, press and travel agents came ashore with unanimous, unbridled praise: she was the most spectacular liner of all time!

I met the late Martha Levin in her beautiful New York City apartment on a winter's morning in 2000, some sixty-five years after the maiden voyage of *Normandie*. We were surrounded by some great antiques, a large grand piano and lots of silver-framed photos. It was one of those grand, but almost bygone Manhattan abodes. She brought out from a closet a thick stack of steamship memorabilia – those oversized menu cards, passenger lists, a few postcards and carbon copies of long-faded passenger tickets. Mrs Levin recalled:

> I had two French teachers in New York, but my mother insisted that the best way to learn French was to go to France itself. So, we closed our apartment and even sold the furniture, and set sail in January 1934 aboard the *Île de France*. There was a big strike in France when we reached Le Havre. Even the trains stopped running. But the French Line, the CGT, had buses at the train station on the quayside to take everyone from the *Île* to hotels. Later, we reached Paris, where we lived for a year.

After a year, however, by the spring of 1935, Martha and her mother had decided to return home to the United States, but were undecided on

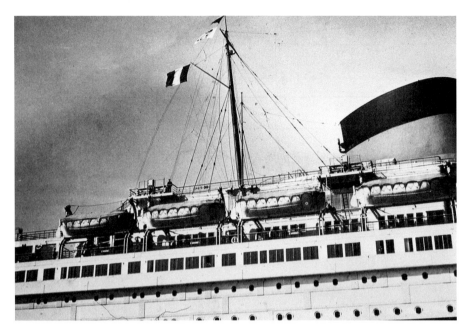

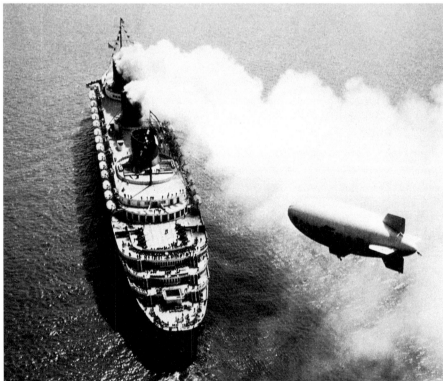

the precise date and which ship to travel on. They had open tickets with the French Line. They might have selected *Paris*, *Champlain* or *Lafayette*, or sailed again on the celebrated *Île de France*.

Mrs Levin remembered:

We saw an ad in the Paris edition of the *Herald Tribune* for the maiden voyage of the *Normandie*, the new French flagship. We were free spirits mostly, still pondering, but mother was intrigued by the idea of such an exciting trip and so we decided to book passage. We traveled in second class.

We began our journey on the French Line train from Gare St Lazare in Paris to the big, brand new terminal maritime at Le Havre, which was built especially for the huge *Normandie*. It was all very exciting. At the terminal, there were great crowds, bands playing. There were great senses of festivity and excitement! I remember seeing Colette [the famed French novelist], who was sailing as well.

The maiden voyage to New York was a calm crossing. It was early June and the weather was delightful. But the vibration was so great that glass holders had to be cushioned with towels. The ship really needed more time at the shipyard and for the sea trials, but the French Line was hell-bent on surpassing Cunard and their *Queen Mary*. First class and even second class were, as I remember on that crossing, not rigidly closed off. We were taken on a guided tour of first class and this included the kitchens. I remember bunches of big purple grapes hanging from the ceilings. The food was beyond compare. Even in second class, you could have any kind of food. The variety was endless. It was all spectacular, even better than in Paris. We had lived rather frugally in

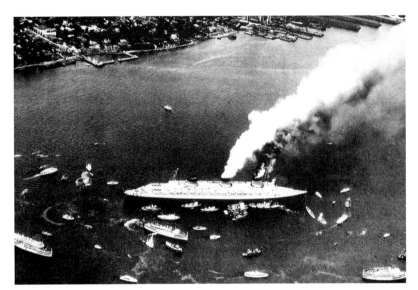

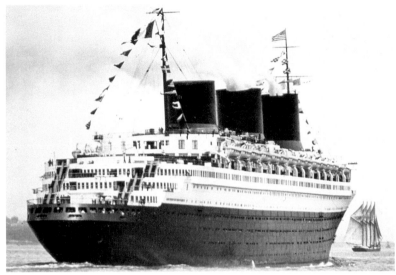

Above: Surrounded by escort craft, *Normandie* waits in the Lower Bay, New York, before proceeding upriver to Pier 88. (Cronican-Arroyo Collection)

Above right: She was immediately appraised as one of the most beautiful-looking liners of all time. (Vincent Messina Collection)

Right: Horns sounded and steam whistles screeched. *Normandie*'s maiden arrival into New York was one of the greatest ever accorded to that port. (Cronican-Arroyo Collection)

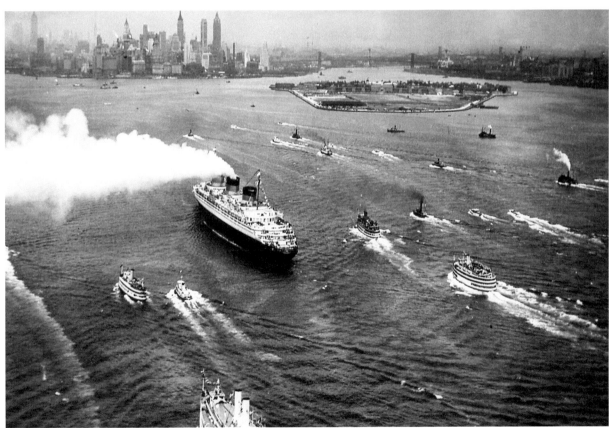

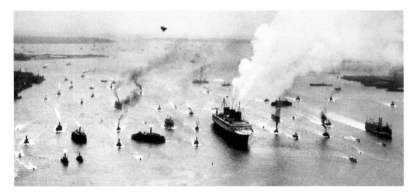

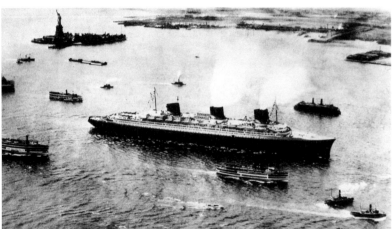

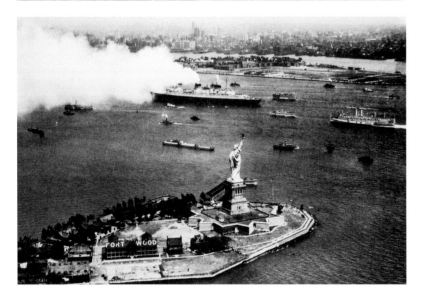

Left: Even Mickey Mouse mounted on a barge was there to greet the magical *Normandie*. (Cronican-Arroyo Collection)

Centre left: *Normandie* proceeds off Lower Manhattan, with another present from the French, the Statue of Liberty, on the upper left. (James Sesta Collection)

Below left: Two French treasures – the ship and the Statue! (Cronican-Arroyo Collection)

Paris, which had become rather expensive by 1935, and so dining on the *Normandie* was like a fantasy land. We also heard rumors that over 500 ashtrays had been taken as souvenirs.

I wandered about the ship quite a lot. I even saw Madame Lebrun, the wife of the French president. Every day had added excitement. There was actually a sense of electricity. But I was feeling unhappy as well onboard the *Normandie*. I did not want to leave France and then not knowing if and when we might return.

The crossing was successful – she averaged a record-breaking 29.92 knots for one twenty-four-hour period and her highest speed of all was 31.37 knots. *Normandie*'s maiden crossing was triumphant. Soon after she had passed New York's Ambrose Lightship, stewards passed the Blue Riband pins while a giant blue pennant was unfurled from her mast.

Triumphant and glorious, the sleek *Normandie* won the prized Blue Riband on that maiden crossing. She made headline news everywhere. Martha Levin concluded:

There was a huge reception in New York harbour. Horns from all kinds of boats were going non-stop. It was truly a reception fit for a queen! Everyone was on deck and everyone was taking pictures. Later, we had a long wait on the dock, standing under the letter 'L' for Levitt, my family name then. We were traveling with several of those big trunks. Everyone was trusting back then. You could leave your camera out, for example, and it would remain unattended. But someone on Pier 88 that day stole many cameras just for photos of the maiden voyage. That night, the ship and her arrival were big news in all New York City newspapers.

Only one thing marred an otherwise wonderfully successful first trip. Frank Braynard later wrote:

> The ship suffered from great vibration. Certain staterooms were unliveable, Vladimir Yourkevitch told me years later. Trunks placed in the middle of a few of the third-class staterooms were likely to spring to life and follow passengers about the room. Persons attempting to speak heard their words shaken into oblivion. Mr Yourkevitch blamed this condition on the ship's propellers, stating that he had been overruled in his selection. Much of the trouble was later eliminated when the offending units were replaced by Yourkevitch-designed propellers. Alternately, all fast ships seem to have had this trouble. A good deal of the same happened with the old *Deutschland*, the famous *Mauretania*, the *Bremen*, *Europa* and the *Rex*, and later would plague the *Queen Mary*.

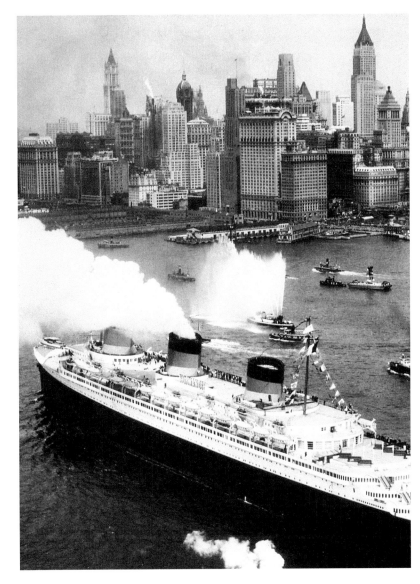

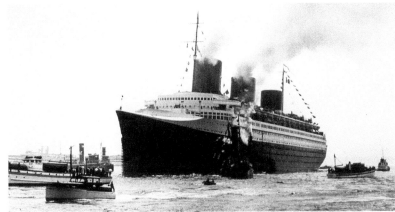

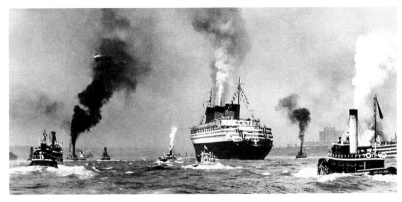

Above: A glittering age: a great liner and the great skyscrapers! (James Sesta Collection)

Above right: The shores are 'black' with people as *Normandie* arrives for the first time. (James Sesta Collection)

Right: *Normandie* mid-Hudson, approaching the famed Chelsea Piers. (Cronican-Arroyo Collection)

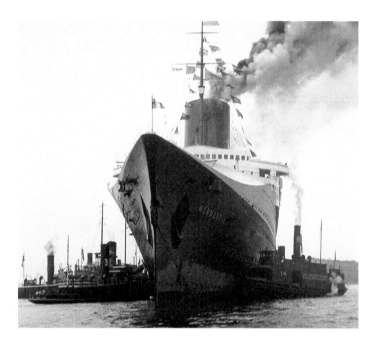

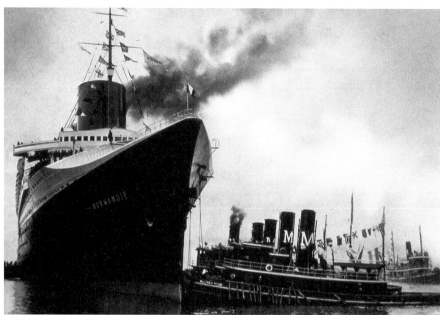

Above: Tugs begin to move the 1,028ft-long liner into the brand-new, but still incomplete, French Line terminal at the foot of West 48th Street. (Cronican-Arroyo Collection)

Above right: Moran tugs carefully and proudly attend to the huge French flagship. (Cronican-Arroyo Collection)

Right: The third funnel was a dummy, as is evident in this maiden arrival photograph. (Author's Collection)

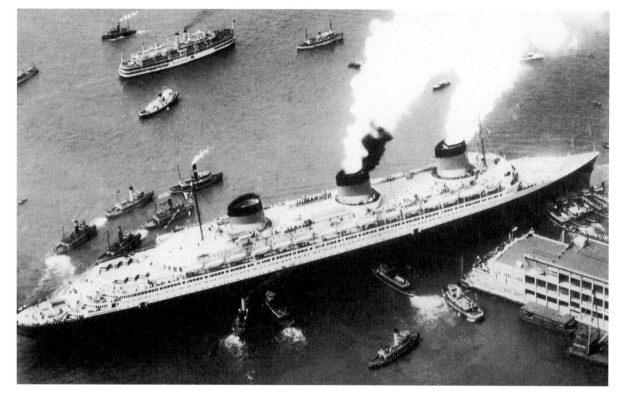

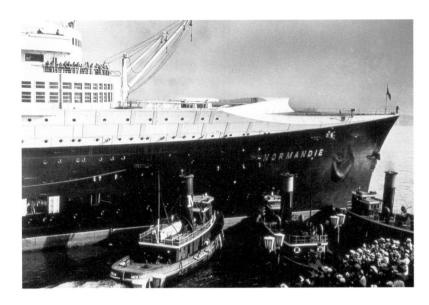

A close-up of the bow as tugs begin the turn into Pier 88. (Cronican-Arroyo Collection)

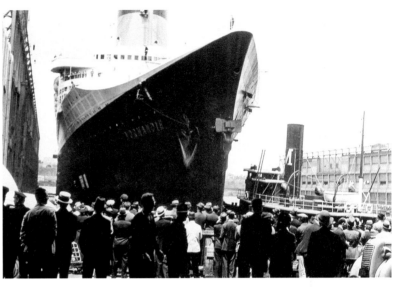

Safely secure and tied up at the 1,100ft-long Pier 88. (James Sesta Collection)

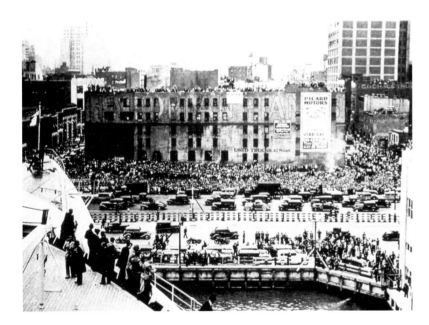

Thousands have gathered along Manhattan's West Side for the first glimpses of the docked *Normandie*. (Cronican-Arroyo Collection)

It was reported, at the conclusion of the *Normandie*'s maiden voyage, about 300 spoons and some 500 small ashtrays had been stolen as souvenirs. The only criticism not shedding complete credit upon the service was that most public announcements were made over the loud speakers in French. One somewhat disgruntled passenger got back at the French Line by darkly hinting that he knew the *Normandie* was nothing more than an aircraft carrier, cleverly designed and only waiting for war to be put into the French Navy.

As the jubilation quieted somewhat during the summer of 1935, the French Line quickly realised that almost all of *Normandie*'s passengers were Americans, and most of them in first class. There were few French and next to no British. Consequently, a short, three-night promotional 'cruise' – the first for *Normandie* – was planned for July. It took her around the British Isles. She would become more familiar to the British, the British press and, in particular, British travel agents.

Beginning in October, and accepting weaknesses in her design, the French Line curtailed *Normandie*'s intended transatlantic schedule for an elongated refit of alterations and, in whispered tones, improvements. The four propellers were replaced with ones of a four-bladed design, the bridge

Above: The great bow had superb form – a marine architect's pride! (French Line)

Above: Typically, the initial coating of black paint on the hull has peeled during the maiden crossing. (Cronican-Arroyo Collection)

Right: *Normandie* looked beautiful along 'Luxury Liner Row'. (Cronican-Arroyo Collection)

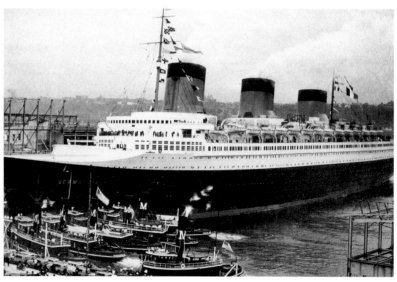

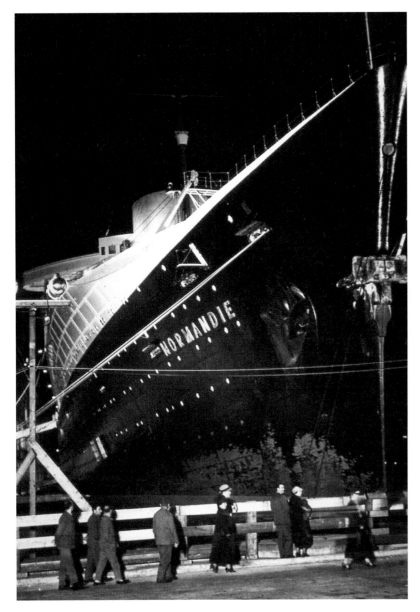

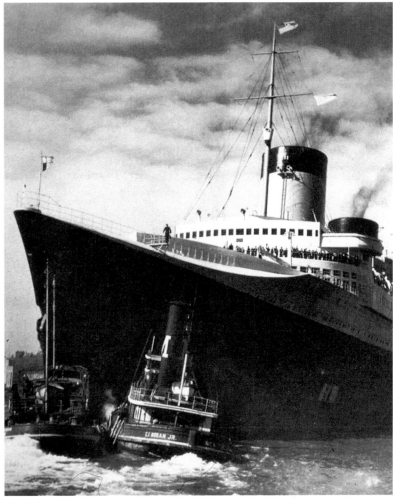

Left: By night, the towering *Normandie* was especially alluring – like a beautiful woman! (Cronican-Arroyo Collection)

Above: Sailing home: departing New York on the eastbound maiden voyage. (Frank O. Braynard Collection)

wings were enlarged and, in appreciation of severe weather conditions, her name in lighted letters placed between the funnels was removed. Within, six of the twelve light towers in the main dining room were taken out to create more space, and a tourist-class lounge was removed and replaced with thirty-two passenger cabins. A totally new lounge was

created, however, aft on the boat deck. This was done to stiffen the ship and reduce vibration. In addition, 80 tons of steel were added to her stern and 200 tons of pig iron to her forward ballast to keep her trim. Almost happily, the French spent an additional $500,000 on the ship. The results: vibration was greatly reduced and she was re-measured from

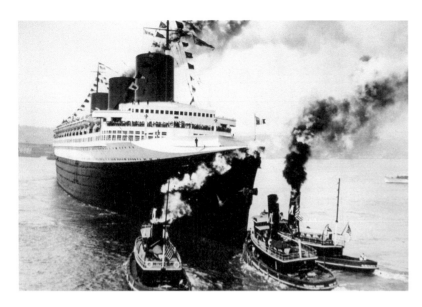

Above: Farewell *Normandie*! Another speed record on the return to Le Havre. (James Sesta Collection)

Right: An aerial view of the just-arrived *Normandie* at Pier 88, New York. (Frank O. Braynard Collection)

Below: A sectional view from the sea trials in spring 1935. (Cronican-Arroyo Collection)

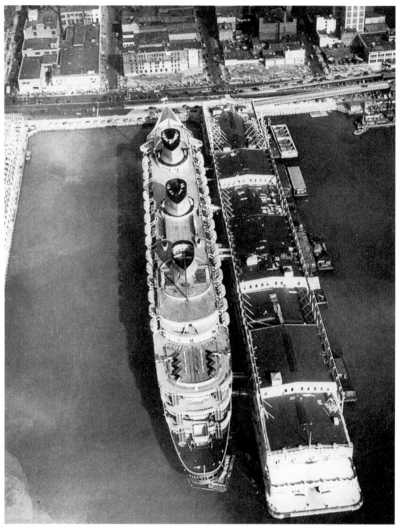

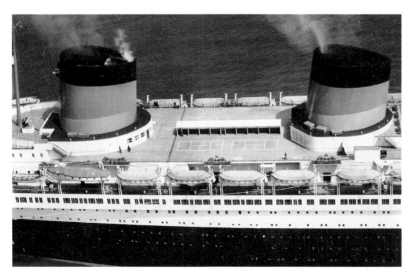

79,283 tons to 83,432 tons, thereby surpassing the 80,773grt of the new *Queen Mary*, due into service in May 1936. The French would continue to have the world's grandest as well as largest liner. But in 1940 Cunard, and therefore Britain, regained the title of having the world's largest ship, liner or otherwise. The 83,673-ton *Queen Elizabeth* was the new champ.

Normandie was the world's fastest liner for little more than a year with a top speed of 29.98 knots. She held the coveted Blue Riband. But in August 1936, *Queen Mary* swept the seas with a run of 30.14 knots. A fierce race followed. *Normandie* regained the title in March 1937 with 30.9 knots and

Another sectional view of this extraordinary ship. (Cronican-Arroyo Collection)

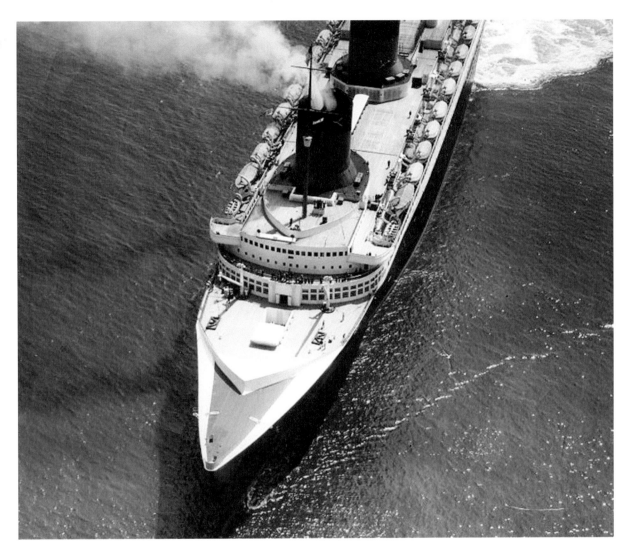

by August had achieved 31.2 knots. The rivalry ended, however, in August 1938 when *Queen Mary* proved the fastest, at 31.6 knots.

Unquestionably, *Normandie* was quickly and firmly dubbed the most luxurious ocean liner ever built. 'It was as if Hollywood and the sets of those great musicals had gone to sea,' said Richard Faber, the New York City-based ocean liner memorabilia dealer and collector. 'She was the ultimate ship in every way. She was big, fast, innovative, the absolute standard-setter then and now.' Construction on Pier 88 was hurriedly brought close to completion in time for the gala maiden arrival and soon

there was a rush in bookings, especially for first-class quarters that began from $275 for the five-day passages.

Throughout the late 1930s there were near-continuous comparisons between *Normandie* and *Queen Mary*. Ever conscious of money and spending, the American press seemed to stress that while *Normandie* cost $60 million, the Cunarder was built for less than half that, at $28 million. Indeed, the French liner was much more luxurious, even stunning, but *Queen Mary* was a greater economic success and much more popular with travellers in all classes.

ALL GOLD & GLITTER

The readers of American newspapers and magazines were flooded with statistics about *Normandie*. She carried 14,570 tablecloths, 226,000 napkins, 150,000 plain towels and 38,000 bed sheets. The French Line offered fantasy statistics as well. If her 600,000 pieces of cloth were sewn together into a vast quilt, they would measure 500,000 square yards or enough to completely cover the 102-floor Empire State Building. Her kitchen was staffed by no less than 200 chefs, who used 56,860 plates, 1,650 salt and pepper boxes, and 28,120 cups and saucers. Her shopping order was vast: 70,000 eggs, 7,000 chickens, 35,000lb of butter, 175,000lb of ice, 7,000 gallons of wine, 2,600 bottles of liquor, 4,000 gallons of beer and 9,500 bottles of mineral water.

One of *Normandie*'s greatest attributes was her public spaces. Yourkevitch and other designers eliminated those huge, central uptakes and in consequence created vast passenger spaces. She had the largest public rooms of her time. Ocean liner historian Pine Hodges noted:

Inside, the *Normandie* generally embodied a combined moderne and art deco scheme of interior decor, practically unrivalled either ashore or on other ships … The use of divided uptakes permitted a 'grand enfilade' on a scale never before achieved aboard any liner … A person standing amidships in the embarkation hall or in the theatre just forward, could look aft through the first-class lounge and smoking-room, up its processional aft staircase to the grill room, and see daylight, over five-hundred feet aft. The embarkation hall was arranged in a unique 'split-level' arrangement, centred between four double-sided elevators, and the hall was visible from the exposed passages of four decks. The main staircase descended forward from either side outboard of the paired elevator shafts, doubling-back aft and finally ending in the great three-deck-high dining room, which was 305ft long, longer than the Hall of Mirrors in Versailles. Lalique glass figured prominently throughout, in the form of cut-glass covers for numerous vertical fluorescent fixtures, urns, pylons, and mirrored surfaces. The French artist Dupas painted unique murals on large glass panels, which graced the main lounge; some of these panels still exist today in the Metropolitan Museum in New York. The 308-seat theatre was the first full-production playhouse theatre ever built into a liner, and this had a unique, rear-projection screen for first-run movies from either shore.

No single designer can truly be attributed to *Normandie*'s great interior style and beauty. Instead, it was like a roll call of the finest deco designers: Jean Dunand, Pierre Patout, F. Dejean, Jean and Joel Martel, Raymond Subes, Leon Baudry and Emile-Jacques Ruhlmann.

Welcome aboard at Pier 88. (Cronican-Arroyo Collection)

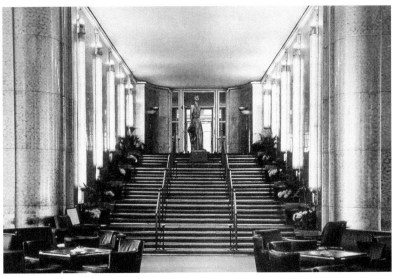

Sumptuously elegant: *Normandie*'s public areas flowed like no other ship. (French Line)

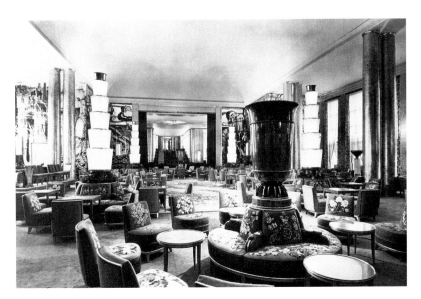

The exceptional grand salon, highlighted by, among other decorative touches, great Lalique 'towers of light'. (French Line)

Normandie's maximum capacity was for 1,972 passengers divided into three classes, but as much as 75 per cent was devoted to first class. Lewis Gordon remembered:

It was the first-class section that was the absolute sensation on board the *Normandie*. Second class was pleasant and even comfortable while third class was all but forgettable. To truly sail aboard the *Normandie* and have the legendary experience, it had to be first class and first class only. Of course, this implied not only money, but the clothes and social style and manners that accompanied it. It might be compared to spending five days and nights at Versailles and all that such an experience included – from the long, extensive dining, to the rituals from afternoon tea and pre-dinner cocktails, to just the right clothes and all the accompanying changes – and all from morning until night.

The late John Gillespie, a New York Harbor historian and author, said:

She was so lavish, like nothing we had ever seen, but actually had come to expect from the French. After all, the test run in many ways was the great *Île de France*, commissioned eight years earlier. But mostly, I

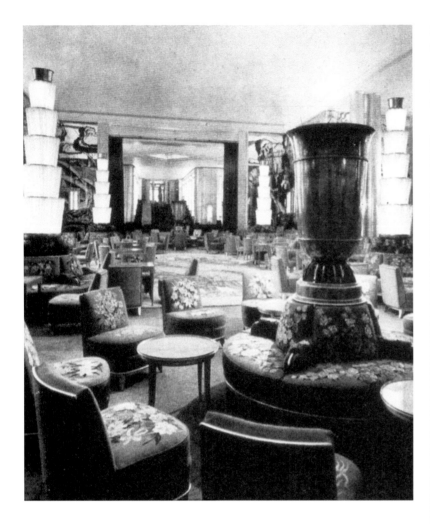

Left: Another view of the grand salon where the base colour was red. (French Line)

Below: Elegance at sea: an evening in the grand salon. (James Sesta Collection)

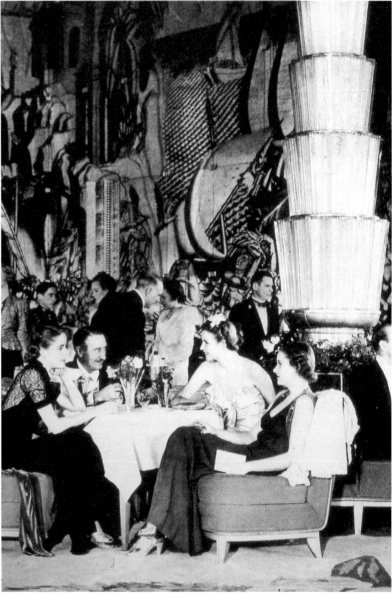

remember the smell of the *Normandie*. It was a combination of fresh furnishings, expensive perfumes and those odorous French cigarettes.

The late John Havers was a Union-Castle Line purser as well as an avid ship watcher at Southampton beginning in the 1930s:

> The *Normandie* was of course the most exceptional ship – more so than the *Bremen* and *Europa*, the *Empress of Britain* and, I dare say, even our own great *Queen Mary*. The *Normandie* needed not just a tender but a flotilla of them [when anchoring in the Solent rather than docking at Southampton]. We would meet more film stars on the *Normandie* tenders

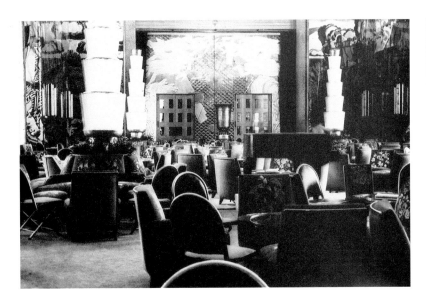

Folding chairs were added to the grand salon during more festive occasions. (James Sesta Collection)

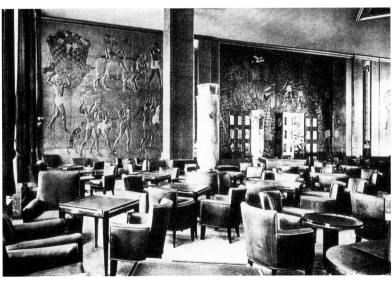

The grandly styled smoking room. (James Sesta Collection)

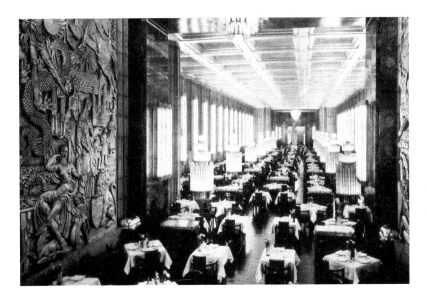

There were over 300 items on gala dinner menus aboard *Normandie*. (Cronican-Arroyo Collection)

than those of any other liner. On board, she had the most distinctive smell: French cigarettes and expensive perfume. Stepping aboard was a shattering experience. The whole ship seemed to be lacquered gold – gold everywhere. There was a great stairway descending into the main restaurant. So large, that restaurant could easily have held one of the Channel steamers of the time. The floors seemed to be of black marble and fountains of light accentuated the gilded furniture. We even visited the inside of the huge, third funnel, which was the dog kennel. There was never a ship like this one!

The late Arthur Taylor, a waterfront reporter at Southampton, often visited *Normandie*:

Comparisons between the new *Normandie* and the new *Queen Mary* were common in the 1930s. The *Queen Mary* was described as an evolutionary vessel, a natural development from previous North Atlantic Cunarders, while the *Normandie* was described as revolutionary. The *Normandie*'s streamlining was carried to the limit, and it was said that she had the perfectly designed hull. There was more gold in the

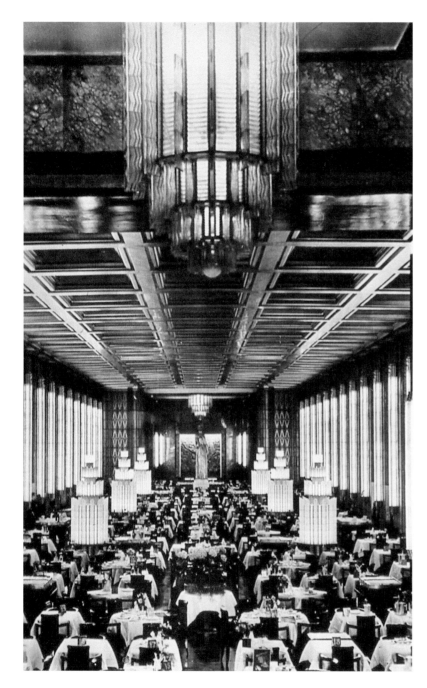

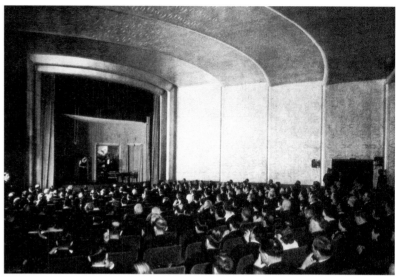

The first full cinema on an Atlantic liner was aboard *Normandie*. (Cronican-Arroyo Collection)

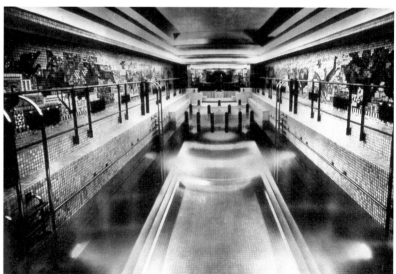

The French Line promoted the fact that the main dining room was longer than the Hall of Mirrors at Versailles. (Author's Collection)

The indoor, tiled pool measured almost 100ft in length. (Cronican-Arroyo Collection)

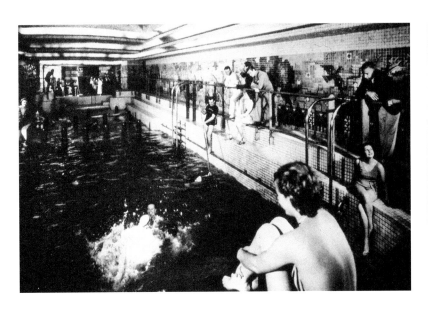

The pool was another popular on-board amenity, including late-night swims after dinner. (French Line)

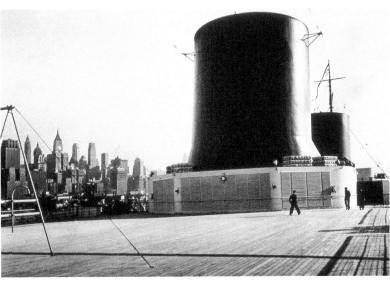

The vast, upper, outer decks aboard *Normandie*. (French Line)

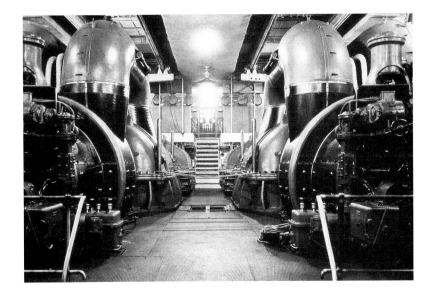

The cavernous engine room of the largest liner in the world. (French Line)

Normandie than any other liner, and glass was used extensively. Actually, the French Line pointed out that glass was chosen not as a gimmick but for practical purposes as it needed no painting, could be easily cleaned and, all important, it was non-flammable. Unlike all the other liners, the *Normandie* never visited the docks at Southampton, but anchored on each of her calls at Motherbank, off the Isle of Wight. Seven tenders used to carry passengers, mail and baggage to and from the ship – an activity non-existent today.

Actress-authoress Maria Riva, the daughter of Marlene Dietrich, crossed aboard *Normandie* with her film star mother. She recalled:

The *SS Normandie* was not really a ship. Oh, she had tonnage, ballast, a captain and a crew, but they were merely camouflage, assumed by an incredible goddess to enable her to transport her temple and its worshippers across the seas. All of us privileged to know her, loved her. She was the greatest ocean liner of them all.

And the *Normandie* was France. She was the epitome of style, taste, quality and artistic perfection. And yet for all her opulence, her grandeur,

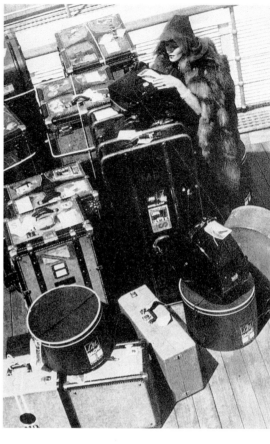

Famous passengers: Maurice Chevalier prepares for a crossing. (Author's Collection)

Marlene Dietrich was one of *Normandie's* favourite passengers. (Author's Collection)

Dietrich departing from New York for a long summer in Europe. (Author's Collection)

her majesty, she had a loving nature, a caring serenity, a strength and dependability.

In the vast lobby, I remember there were four free-standing elevators. Even the Waldorf had nothing like this. Here the notes of Irving Berlin and Cole Porter jumped and swung. You expected Fred Astaire and Ginger Rogers to spin past, cheek to cheek. The whole ship was a Busby Berkeley production with class!

The late Thomas Hoving, an art expert and editor of *Connoisseur* magazine, wrote in 1984:

When it comes to elegant 'floating palaces' of the 1930s, nothing can beat the *Normandie*. To Ludwig Bemelmans, that great bon vivant and traveler, the heart and soul of the luxury liner's artistry was her Grand Salon, a 'room full of silver, gold and glass, large as a theater, floating through the ever clean, endless ocean just outside the high windows'. Passengers were overwhelmed by the beauty of the glass panels depicting navigation, by Jean Dupas, and the enormous gold-and-silver lacquered mural leading from the salon to *fumoir* (smoking room) signed by both Dupas and the renowned Swiss master of lacquer Jean Dunand. Dunand and Dupas created 32 dazzling panels, each of them painstakingly

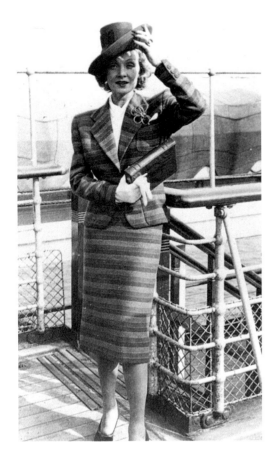

Marlene Dietrich occupied the splendid Deauville Suite. (Author's Collection)

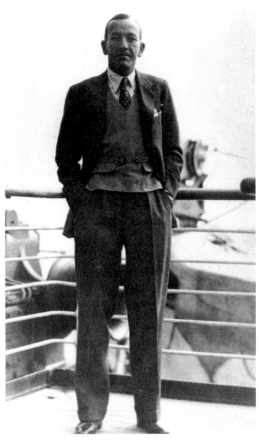

Noël Coward was another *Normandie* passenger. (Author's Collection)

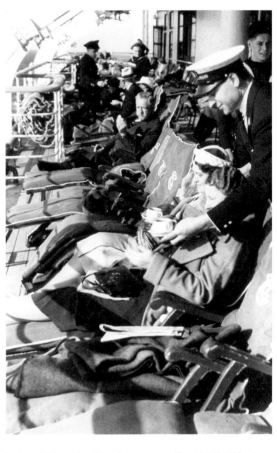

Leisurely travel – five days across the North Atlantic. (French Line)

painted and rubbed on fireproof gesso; together, they formed an entity measuring some 18 feet high by 26 feet wide. It was called *Dawn, the Four Winds and the Sea*, and its central sunburst seemed to shine as if illuminated by inner searchlights.

Apart from New York, Frank Braynard visited *Normandie* at Le Havre:

All through France in the fall of 1938, I saw posters of the *Normandie* inviting people to see her on her 100th Atlantic crossing. So I cut short my sketching tour of French cathedrals and trained to Le Havre. I found the great French flagship in dry dock and, without a pass or even a request to show credentials, I walked aboard. Her wonders were once again evident. She was the most extraordinary ship – and in every way. I spent hours on board exploring. I later found a comfortable spot that overlooked the nearby *Paris*. I began to sketch her. But then, with at least 15 minutes of sketching yet to go, a sailor appeared. I feared being asked to leave. Instead, he smiled and with great care cleaned the window out of which I was peering and then nodding at me as I departed. French courtesy!

Bon voyage! Preparing for a voyage on the most luxurious liner of her time. (Cronican-Arroyo Collection)

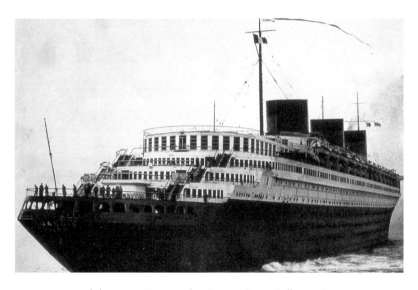

A stern view of the great *Normandie*. (James Sesta Collection)

Ocean liner collector and historian Steven Winograd cherished *Normandie*, but from afar. Born in the mid-1950s, he missed seeing the great French flagship:

> She was the greatest star ever to sail the seas, but a star that burned brightly, almost too brightly, and all too fast. She was all gold and glitter and so stunning that she actually intimidated many. Sadly, she had only 4½ years of actual service. She had a great sense of French integrity and was the last word in just about everything. She was the finest of the finest, the best of the best. She was a world class ship before the world was actually ready for such a class. I first learned much about her in the early 1970s, reading John Maxtone-Graham's superb *The Only Way to Cross*. This was my introduction to the impeccable *Normandie*.
>
> On the outside, she had those stepped funnels, which gave the impression of speed, great speed in fact. She was eye-catching … so modern, so advanced, so different that she somehow made almost all other liners look like old bed jackets!

On board, first-class passengers boarded A Deck and then, using an upward stairwell, found themselves in the three-deck-high entrance hall. The walls were clad in Algerian onyx and accented by strips of hammered glass and gilded bronze created by Subes. Two pairs of lifts were encased in bronze. The lifts had two attendants – one to ask passengers which deck was required, the other to simply press the button.

The first-class public rooms were nothing short of sensational. 'Each were complete and total sensations in themselves,' Lewis Gordon recalled. There was the Winter Garden (with live plants and caged birds), the reading and writing rooms, the theatre (with no less than 400 seats), the gallery-lounge, the grand lounge, the smoking room, the café grill and the dining room. The grand lounge, sumptuous and often compared to the Hall of Mirrors at Versailles, was, according to Lewis Gordon, 'positively and completely breathtaking'. The highlight for many was the four, very large glass relief panels designed by Dupas. They were etched and painted on the reverse side using gold, silver, platinum and palladium, and each had a different theme: *The Chariot of Poseidon*; *The Chariot of Thetis*; *The Rape of Europa*; and the *Birth of Aphrodite*. Four 12ft-high towers of Lalique glass, with seating at their base, created much of the lighting and there were two massive pewter urns placed at each end of the room. The Aubusson carpet, said to be the largest hand-woven carpet ever created, covered the central, hardwood dance floor by day and was rolled up for dancing by night. Its theme was a huge basket of flowers.

The smoking room was another high sensation. 'It had a rich, golden glow,' added Lewis Gordon, 'and was more of French Art Deco design, decor, decoration and taste at its absolute very best.' Jean Dunand created four 20ft-high lacquered panels for this room. Aft was a gilded statue, La Normandie, from which passengers could have the full visual impact of the public rooms, a vista of almost 700ft of lounges, salons, and 'stunning decorative riches', as one passenger noted. Passengers were often left bedazzled. And the café grill was another form of deco – sleek, chrome-framed chairs were set against matching tables. The walls were done in pigskin and the lighting was soft, diffused and totally romantic.

The first-class dining room was another magnificent creation: it was almost 300ft in length, three decks high and was entered by way of a sweeping staircase – well described by French Line publicists as the *grande descente*. Finished in bronze, hammered glass and more of Lalique's masterful work, the room was lighted by thirty-eight panels and twelve light towers. Presiding over the captain's table was a 13ft-high statue, Peaceful Normandy. Down below was the largest indoor pool yet designed for a ship, a creation in tiles measuring 75ft by 19ft. The chapel was described as a 'miniature, sea-going cathedral'.

Altogether, there were 448 first-class suites and staterooms. Most had full private bathrooms; some had a private toilet and shower; others just had a private toilet. The most lavish quarters were the *suites grand luxe*, located aft on the sun deck. Known as the Deauville and Trouville suites, they were the most lavish accommodations then afloat: four bedrooms, a living room, a dining room, five bathrooms, servants' quarters, a pantry and a 45ft private terrace. Each suite was designed with an adjoining two-room suite for additional staff. The decor was expectedly superb, the Trouville Suite having Aubusson tapestries, satin-coloured chairs and lined in ivory leather. Two other suites, the Caen and Route, were similar but did not have expansive terraces. Then there were ten *suites de luxe*, each decorated in Art Deco except one, which was creatively done in Louis XV stylings. The French Line proudly pointed out that no two first-class suites or staterooms were exactly the same, giving each space a 'private individuality'.

Normandie's superb exterior design lives on. Bill Deibert said:

Let's not forget that copy is the greatest form of flattery. In the enlightening book *Damned by Destiny*, you can see clearly that the hull form of the *Normandie* and even the whaleback structure of her bow was directly copied by the Germans in their new *Vaterland* of 1940. Decades later, in 1987–88, Royal Caribbean Cruise Lines deliberately copied the stern of the *Normandie* in their new 73,000grt *Sovereign of the Seas* class, which were built at St Nazaire as well. And then the new 151,000grt *Queen Mary 2* of 2003 used the same tapered paint scheme transition from black to white superstructure at the bow as on the *Normandie*. The QM2's whaleback is exactly copied from the *Normandie*. So, a British liner copied and incorporated some of the French design of the *Normandie*, but 70 years later!

Normandie's interior decor has, of course, been copied, even imitated, to some extent. The French Line repeated decorative touches in the post-war, rebuilt *Île de France* and *Liberté*, while modern-day cruise ships, such as the 122,000grt *Celebrity Solstice* and her four sisters, have some public spaces reminiscent of the great *Normandie*. In 1998–99, when Disney Cruise Lines decided on their first new liners – the 83,300grt *Disney Magic* and *Disney Wonder* – they initially considered a three-funnel design, not only hinting of bygone ocean liners, but more specifically of the legendary French flagship.

Overall, *Normandie* herself was something of a gamble for the French. They had never built a ship of such large and grand proportions. Comparatively, she was twice the size of their previous flagship, *Île de France*. Record-breaking, prestigious and the greatest of floating public relations pieces, *Normandie* never quite fulfilled her economic promise. She was a financial disappointment, having rarely in her four and a half years of service sailed at more than 60 per cent capacity. While *Île de France* often sailed to full capacity, *Normandie* never quite had the same allure – she never sailed completely full. Even in her maiden year she made crossings with less than 1,000 passengers on board and had at least one crossing, in the autumn of 1938 when there were increasing threats of war in Europe, with less than 200 passengers aboard. Comparatively, in 1936 *Normandie* carried a total of 27,200 passengers, whereas her arch rival, *Queen Mary*, had carried 42,000 passengers. Overall, the French government was seemingly very tolerant and most supportive. They were, after all, thinking seriously of a bigger version, the 100,000-ton *Bretagne*, in the late 1930s. According to initial projections, she would have been in service by 1943. The French would then have had a two-ship express service just like Cunard. The idea never came to pass and was abandoned as war clouds approached and the Second World War erupted.

There was some added excitement – and notation – surrounding *Normandie* when it was announced, in the summer of 1937, that the ship would make her first, long, luxurious cruise – a glamorous trip to Rio, no less. She would be operated by Raymond-Whitcomb, then a well-known,

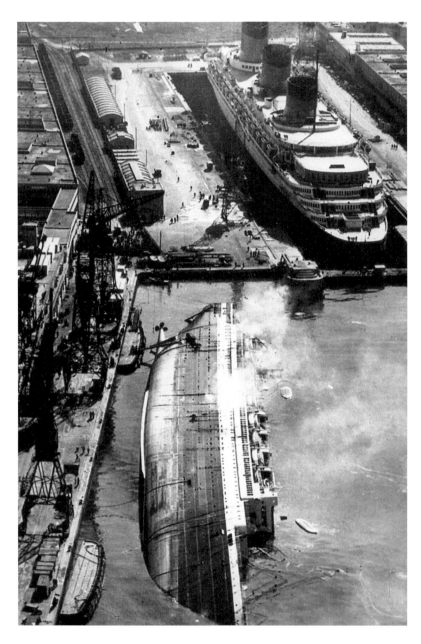

New York-based tour operator. The ship would be styled as all first class, limited to 1,000 passengers. Fares ranged from $790 to just under $10,000 for either the Deauville or Trouville suites. Instantly appealing, the twenty-one-night voyage sold out in fourteen days. While other Atlantic liners offered long winter cruises away from the cold northern winter, a three-week cruise on *Normandie* was exceptional. Newspapers, magazines and travel journals were ablaze with news of the great French liner going to the tropics. She departed on 5 February 1938, calling at Nassau and Trinidad en route, spending five days at Rio de Janeiro. On the return to New York, she stopped at Martinique. Professional entertainers, including bridge and dance instructors, were employed specially for this voyage. There was also a port lecturer and the added attraction of 'personalities from the radio'. A highlight of the voyage, of course, was the famed Crossing of the Line ceremony.

Repeating success, a second Rio cruise took place in February 1939, this one twenty-four days in length, including Barbados and coinciding with the legendary Carnival in Rio. Lee Shubert, the Broadway theatre impresario, was aboard as a passenger. His trip had an added bonus. He visited a Rio nightclub, discovered a young singer-dancer and lured her with a contract to the New York stage. Her name: Carmen Miranda.

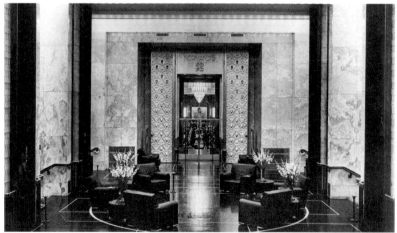

The entrance foyer to the main restaurant. (Author's Collection)

Problems! *Paris* burned and capsized in April 1939 at her Le Havre berth. *Normandie* was temporarily trapped in the port's big graving dock. (Cronican-Arroyo Collection)

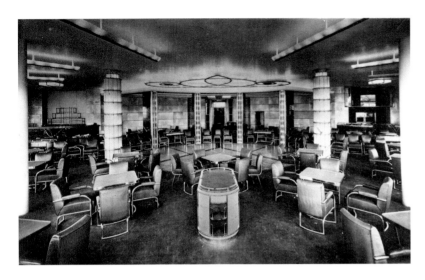

The café grill room used mostly by night owls. (Author's Collection)

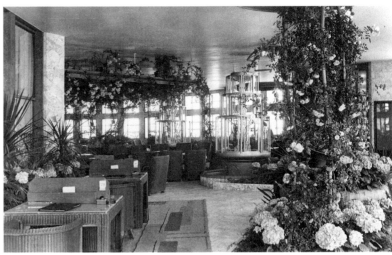

The exotic Winter Garden – a retreat during grey, stormy crossings in particular! (Author's Collection)

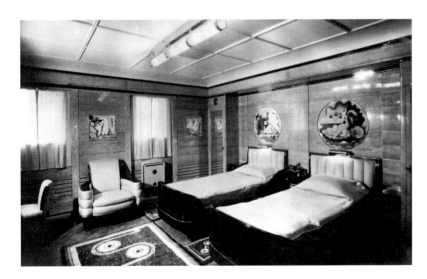

A lavish bedroom in a suite. (Author's Collection)

The late Everett Viez, an avid ocean collector employed by Thomas Cook & Company as a tour director, crossed on *Normandie* in July 1937. He said: 'A major refit was rumored for 1939. Among the changes, the bird-and-greenery-filled Winter Garden was due to come out and be replaced by more suites.' Of course, such an idea never came to pass, no doubt because of the changes in European politics in 1938–39.

Fierce competition for both passengers and press attention continued between *Normandie* and *Queen Mary* in the increasingly tense summer of 1939. An added worry for the French was the fact that *Queen Elizabeth* was due into service in April 1940. These were not the most positive times for *Normandie*.

Frank Trumbour added his thoughts to the classic comparison between *Normandie* and *Queen Mary*:

As much as I love the *Queen Mary*, there is no doubt that the *Normandie* 'stole the show'. Since the *Queen Elizabeth* did not enter commercial service until after World War II, she does not accurately fall into the 1930s competition of big liners (neither was she designed and constructed in the '30s). There were, of course, other glamorous liners of the '30s period – the *Empress of Britain*, the *Rex* and the *Conte di Savoia* – but they were no true super liners in my opinion.

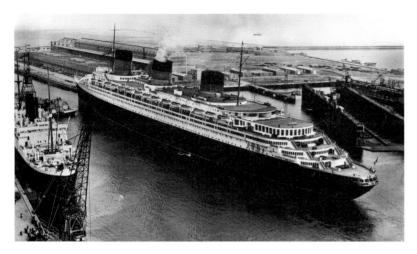

Leaving dry dock at Le Havre. (Author's Collection)

At Le Havre, with *Île de France* berthed behind. (Richard Faber Collection)

Below: Captain Rene Pugnet (left) and Staff Captain Pierre Thoreaux on the bridge. (Photofest)

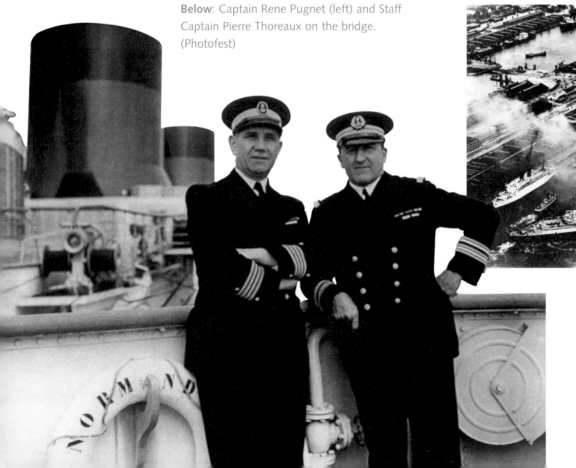

Above: A spectacular aerial view of *Normandie*'s maiden departure for New York – *Colombie* is to the left, *Paris* berthed further back; *Île de France* and the combination passenger-cargo ship *Wisconsin* are in the floating dock on the right. (Author's Collection)

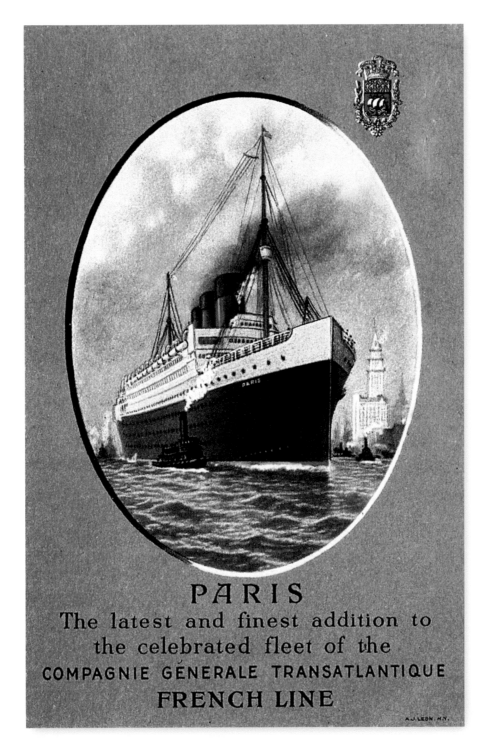

A brochure cover from *Paris* in the 1920s. (Richard Faber Collection)

Looking back: a French Line passenger ticket from 1900. (Richard Faber Collection)

Beginning in the 1920s, French liners were seen as 'the cheeriest way to cross the Atlantic'. (Author's Collection)

The Art Deco period. The 1930s was an age of style, as seen in this poster advertising Villefranche-sur-Mer. (Author's Collection)

Railways created superb 1930s poster art as well. (Author's Collection)

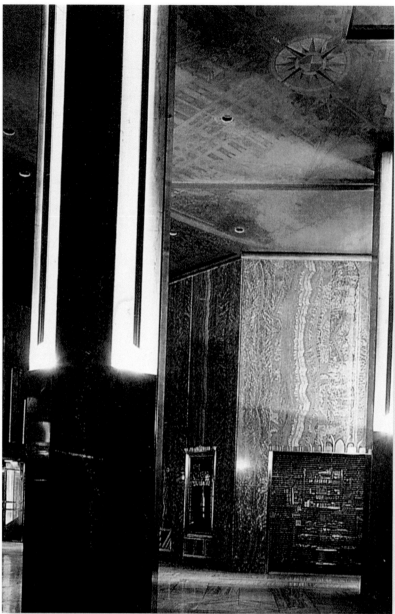

The Art Deco stylings introduced by *Île de France* in 1927 led to its use in hotels, railway stations, department stores, cinemas and, of course, skyscrapers. Here is a classic example: the lobby of New York City's Chrysler Building, completed in 1929. (Author's Collection)

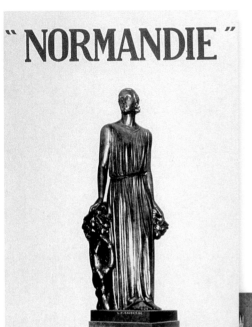

Left: The cover of a brochure
introducing *Normandie*. (Richard Faber
Collection)

Below: Glamour! A preview of the great
Normandie. (Richard Faber Collection)

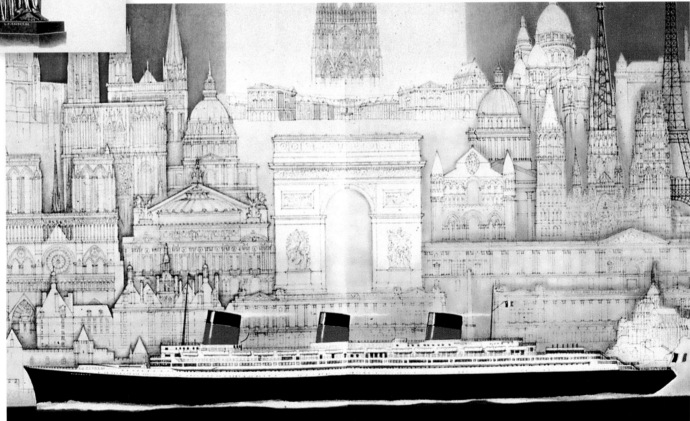

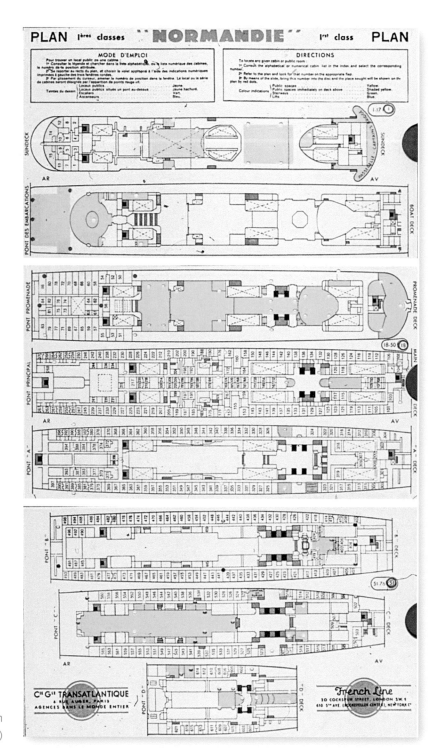

A sample deck plan of the French liner. (Richard Faber Collection)

Normandie had the most alluring profile. (Richard Faber Collection)

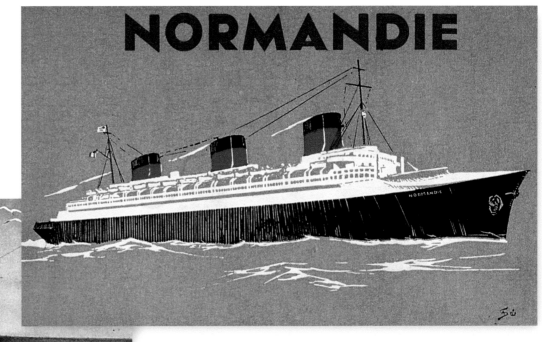

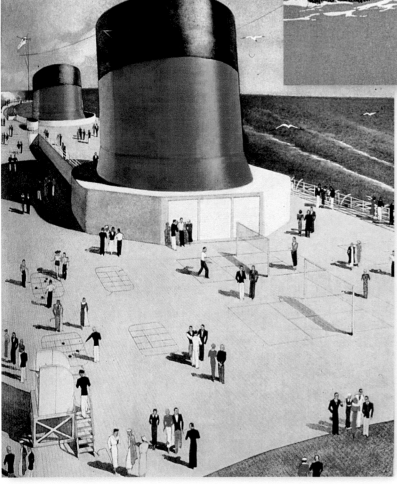

An artist's impression of the ship's upper, open decks. (Richard Faber Collection)

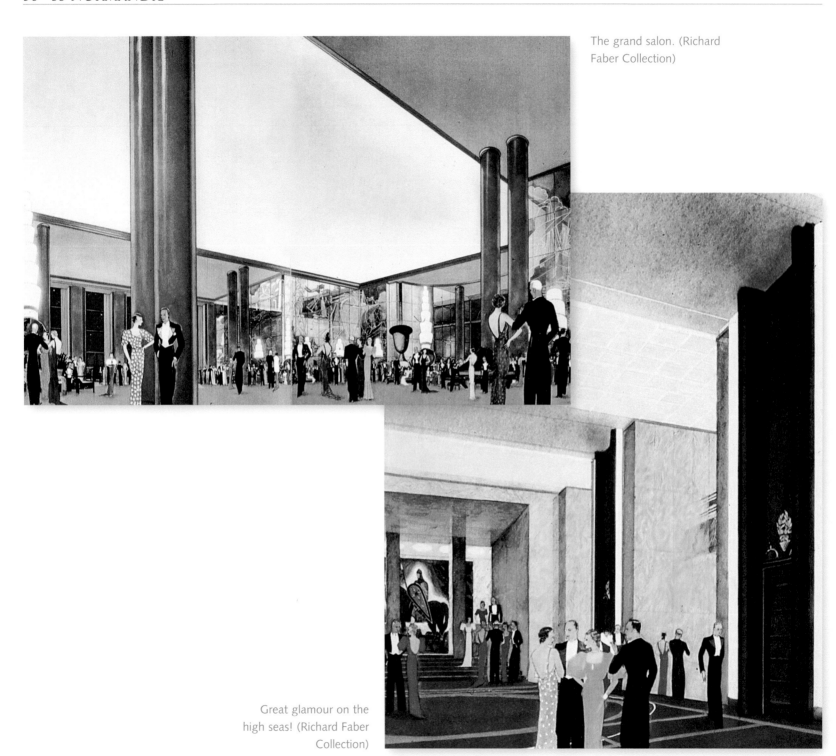

The grand salon. (Richard Faber Collection)

Great glamour on the high seas! (Richard Faber Collection)

Left: The spectacular indoor pool, made to seem bigger and longer. (Richard Faber Collection)

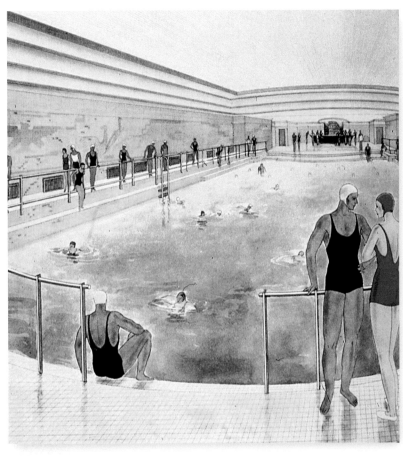

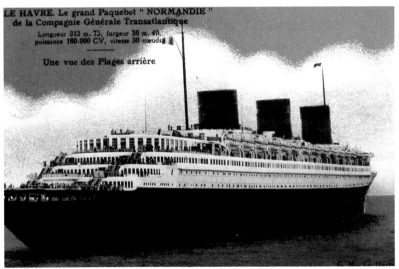

Left: A colour postcard of the ship. (Richard Faber Collection)

Above: The famed poster by French artist Cassandre. (Author's Collection)

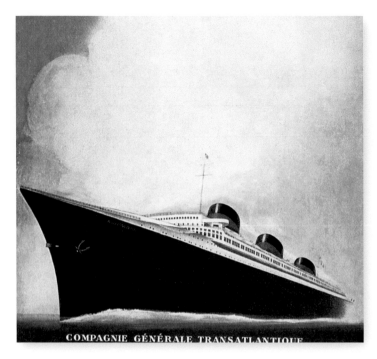

Futuristic-looking in this highly stylised depiction.
(Richard Faber Collection)

Crossing the Atlantic in grand
style! (Author's Collection)

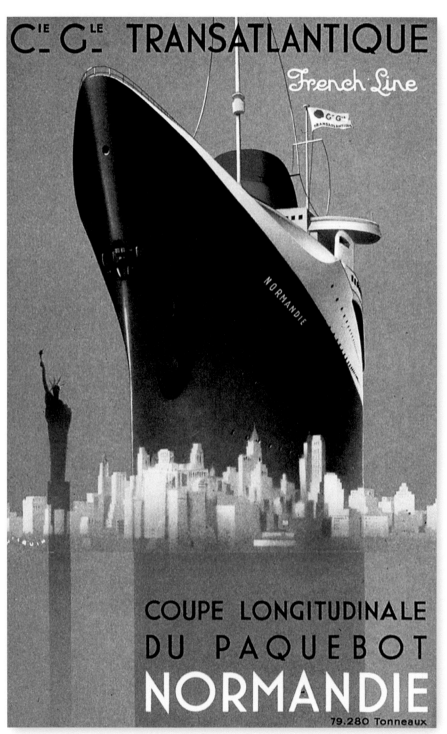

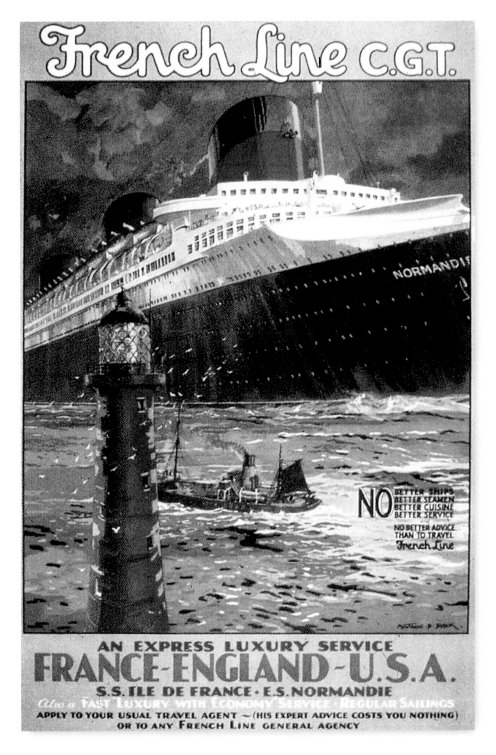

What better way to cross
the Atlantic? (Author's
Collection)

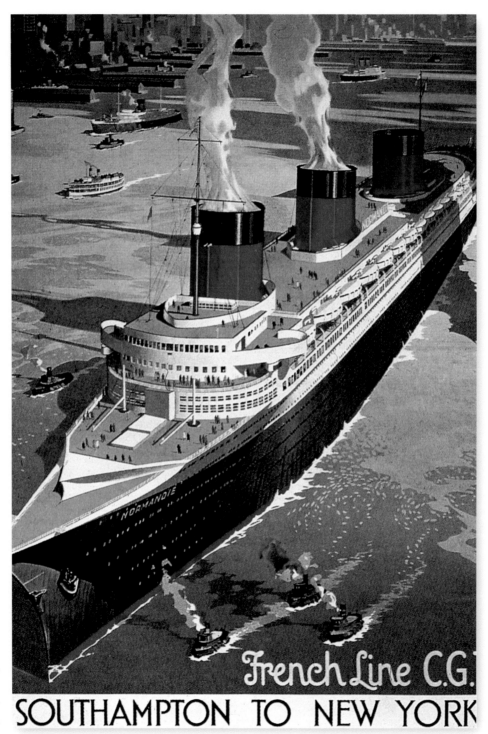

The tugs have been reduced in size to make the 83,000-ton *Normandie* seem even larger in this spectacular poster. (Author's Collection)

The train that ran between the French Line terminal at Le Havre and Paris – the ease of travel! (Author's Collection)

Normandie affected
fashion, the movies,
even toys. (Author's
Collection)

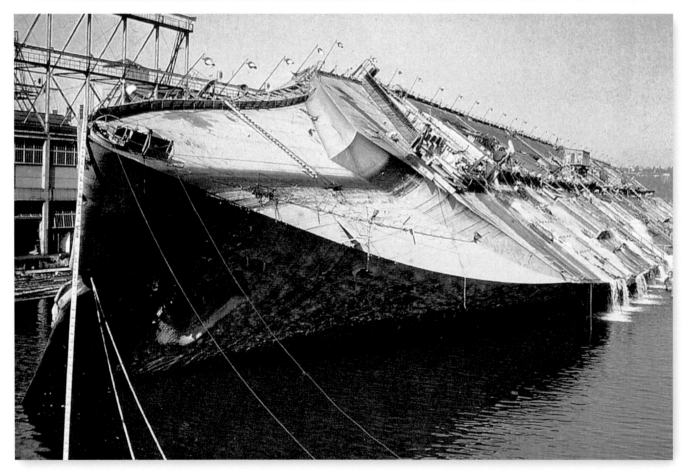

Raising the wreckage
in a rare colour view
from the summer
of 1943. (Author's
Collection)

Another rare colour photograph: *Normandie*'s hull is towed through New York's Kill van Kull, under the Bayonne Bridge, 24 November 1946. (Author's Collection)

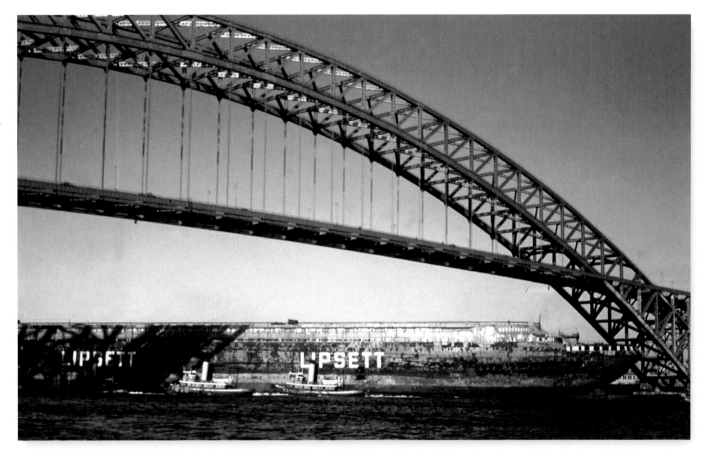

Grand succession: the beautiful *France* departs from New York in June 1973. (Author's Collection)

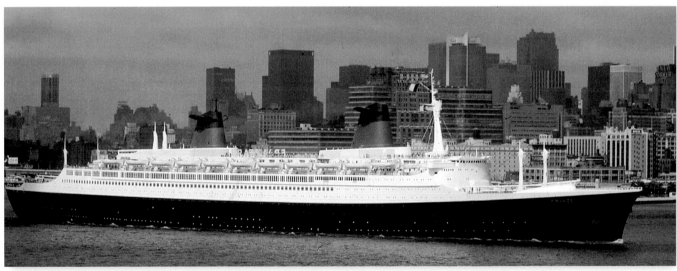

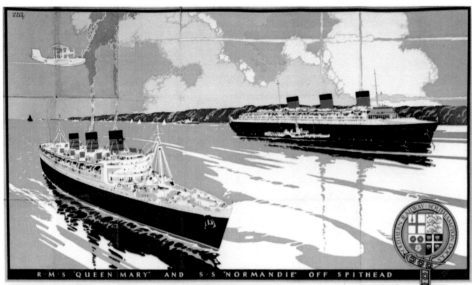

A poster of Southampton Water portraying *Queen Mary* and *Normandie*. (Author's Collection)

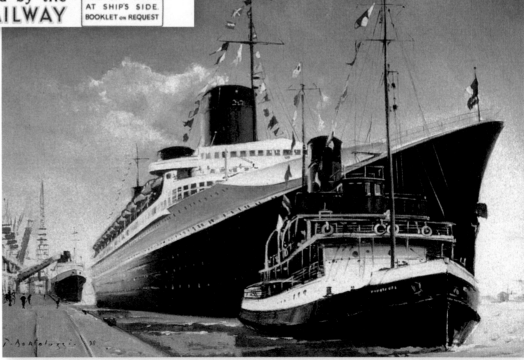

A fine painting at Le Havre by P. Bartolozzi. (Author's Collection)

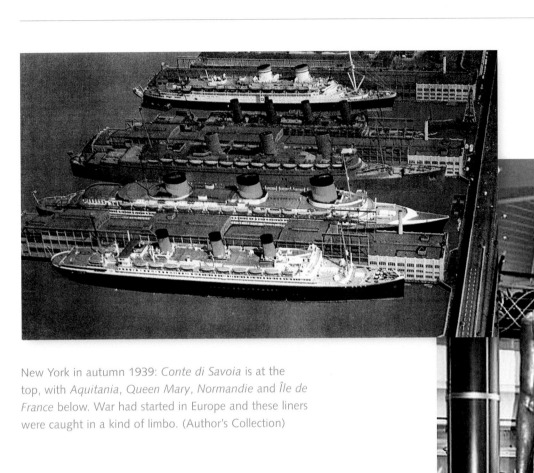

New York in autumn 1939: *Conte di Savoia* is at the top, with *Aquitania*, *Queen Mary*, *Normandie* and *Île de France* below. War had started in Europe and these liners were caught in a kind of limbo. (Author's Collection)

Photographed in 2011, the statue La Normandie in the main restaurant aboard the cruise ship *Celebrity Summit*. (Author's Collection)

A specially colourised view by Anton Loginvenko of *Normandie* departing from Le Havre on her maiden crossing to New York. (Author's Collection)

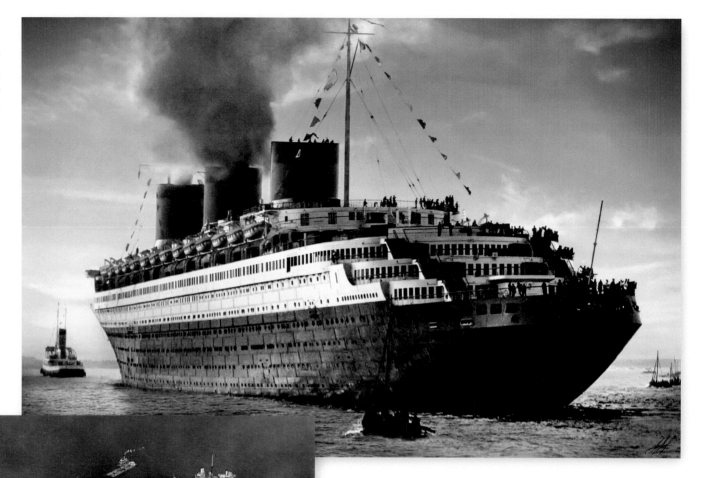

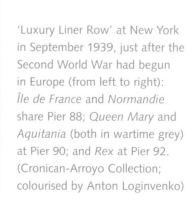

'Luxury Liner Row' at New York in September 1939, just after the Second World War had begun in Europe (from left to right): *Île de France* and *Normandie* share Pier 88; *Queen Mary* and *Aquitania* (both in wartime grey) at Pier 90; and *Rex* at Pier 92. (Cronican-Arroyo Collection; colourised by Anton Loginvenko)

Scenes of cherished items displayed in *DecoDence*, in New York in 2010. Among the items were ashtrays and matches. (Mario J. Pulice Collection/ South Street Seaport Museum)

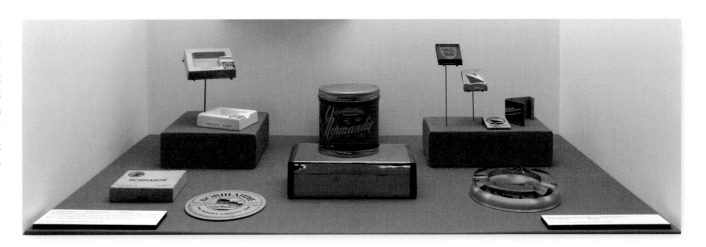

Chairs from the grand salon. (Mario J. Pulice Collection/South Street Seaport Museum)

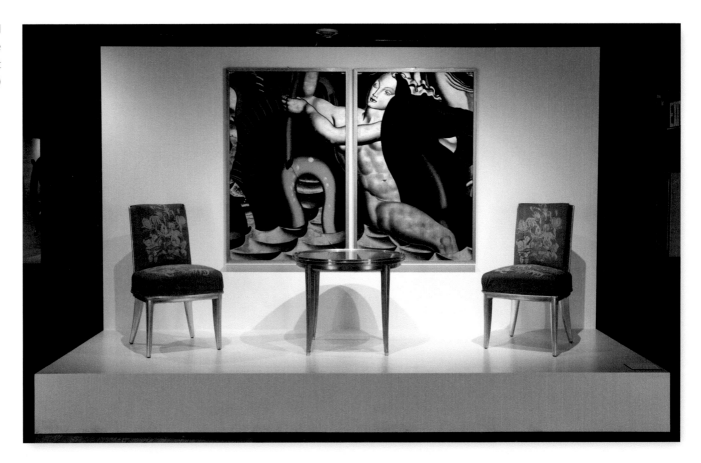

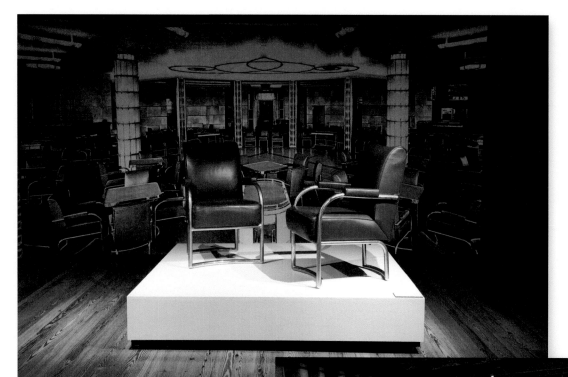

Grill room chairs. (Mario J. Pulice Collection/South Street Seaport Museum)

Chairs from the first-class dining room. (Mario J. Pulice Collection/South Street Seaport Museum)

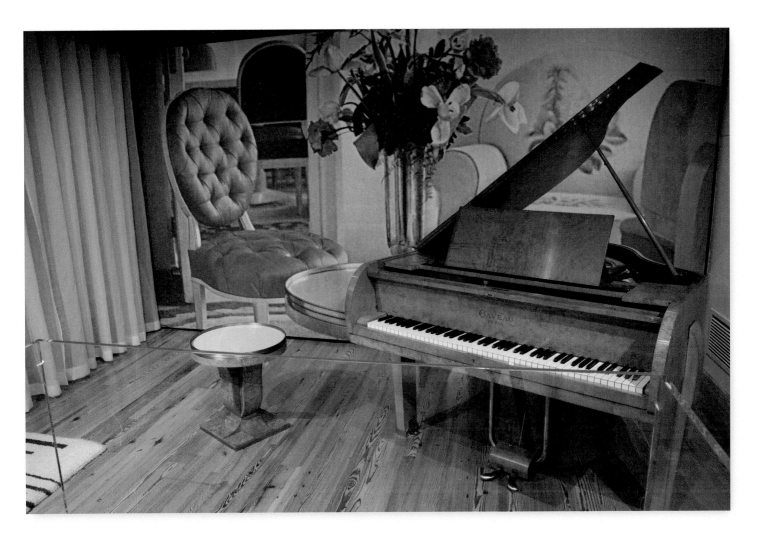

The splendid Gaveau piano from the Deauville Suite. (Mario J. Pulice Collection/South Street Seaport Collection)

Choice items: a phone, blotter, ink well and vase. (Mario J. Pulice Collection/ South Street Seaport Collection)

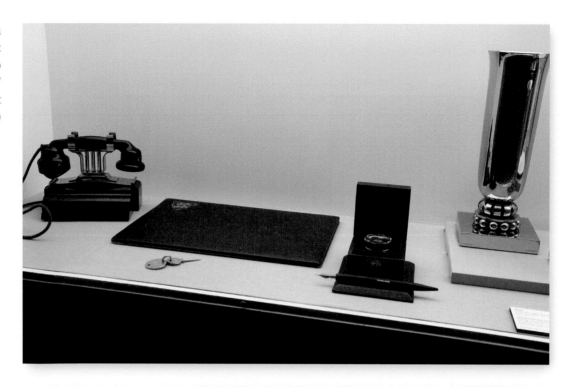

Other amenities included a bellman's suit and chair from a children's playroom. (Mario J. Pulice Collection/ South Street Seaport Collection)

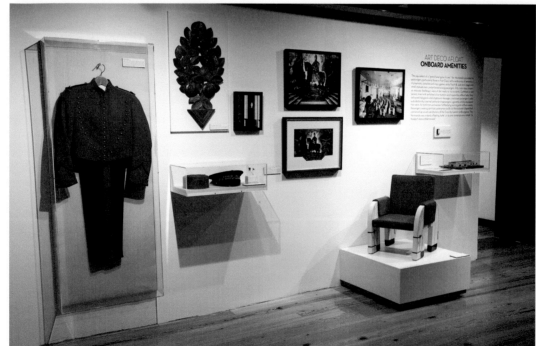

6

A GODDESS LOST

As the dark clouds of war in Europe approached, on 28 August 1939 *Normandie* reached New York for the last time. She was due to sail two days later, but with only 350 passengers on board. At first said to be 'delayed', she was in fact laid up at Pier 88 and would never sail again.

The spring and summer of 1939 were increasingly fraught with tensions in Europe. War was brewing. When *Paris* burned along Le Havre dockside in April, it was quietly said to have been sabotage. Westbound passages were booked up with more and more refugees fleeing European homelands. The late noted fashion designer Pauline Triggere was among them. She later wrote: 'My family and I were very fortunate to leave Europe. My father wanted the fastest ship to freedom and safety – and so we left Paris and caught the *Normandie* to New York. In looking back, it was a rather glamorous way to migrate, to escape.'

The French Line, following instructions from the French government, decided to mothball the giant liner at the foot of West 48th Street. Rather quickly she became a ghost ship; overlays were placed on the furniture, on-board lighting was reduced, much of the crew returned to France and a small skeleton crew of 115 remained to look after the otherwise silent ship. The engines were kept operational, however, in the event she was needed in Europe. Meanwhile, newspaper and magazine articles suggested a varied future for the ship, either as a huge troop transport, or – with touches of enthusiasm – as a rebuilt troopship or even a combination troop-carrying aircraft carrier. US authorities also worried about possible sabotage and passed her over, as France fell to the Nazi armies in May 1940, to the Coast Guard. Saboteurs and Nazi sympathisers were reportedly in and around New York City and its harbour.

After entering the war (following the attack on Pearl Harbor on 7 December), the United States officially seized *Normandie* on 12 December 1941. Once more it was rumoured, but perhaps now more seriously, that she would become an aircraft carrier. However, that was soon dispelled with the decision to use her as a troopship, in the same way as Cunard's *Queen Mary* and *Queen Elizabeth*, then carrying over 10,000 troops (and later 15,000) each.

Due to the pressing needs at American shipyards, and considering the size of *Normandie*, it was decided to convert her for trooping at her Pier 88 berth. Warehouses were quickly rented in which to store her lavish fittings, much of them marked and numbered (in white chalk) for 'return after the war ended by late 1942'. Word along the waterfront was that she would most likely be back in French Line service in 1943, when the war, as they predicted, had ended. So, it all seemed rather temporary: a changeover for the ship and then a hurried conversion process. Her exterior was repainted in wartime camouflage, her name was changed to

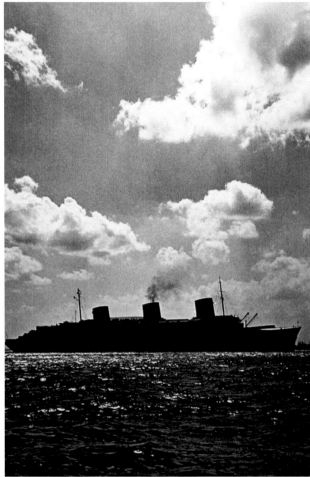

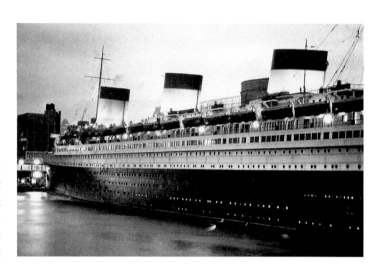

Left: Fateful times! *Normandie* arrives at New York in the politically troubled summer of 1939. (Cronican-Arroyo Collection)

Right: Silent and lonely, the great *Normandie* waits at Pier 88, August 1939. (Cronican-Arroyo Collection)

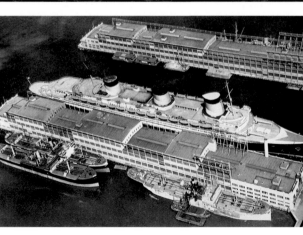

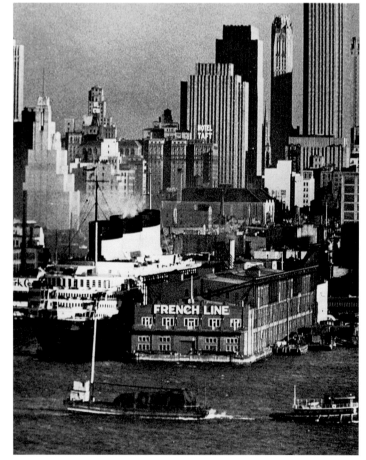

Left: Idle: *Normandie* begins her lay-up at Pier 88 in August 1939. (Author's Collection)

Right: Seen from across the Hudson, from Weehawken, New Jersey. (Author's Collection)

USS *Lafayette* (although it was never quite painted across her bows) and her once lavish interiors were converted to troop berths, mess halls and other military facilities. Rafts were placed along her outer sides, below the boat deck. But there were, in retrospect, some serious mistakes made: fire alarms connected to the bridge were turned off during the conversion; the ship-to-shore fire alarm box was disconnected; and none of the conversion crews (from Todd Shipyard) were specially trained in firefighting. Then there was a disagreement over who controlled the ship – first assigned to the US Navy, she was then transferred to the US Army. Disputes took place and in the end she reverted to navy control.

The ex-*Normandie* was to be hurriedly pressed into service, being scheduled to leave Pier 88 for dry docking in Boston on 12 February and then to sail via Cape Town for trooping out in Australia. Work proceeded at a speedy, almost urgent, but somewhat careless pace.

The columns in the grand lounge were being removed on a typically busy and cold Monday, 9 February 1942. Acetylene torches were used. Nearby, a pile of kapok-filled lifejackets were being stowed. Sparks from the welding torch ignited the heap of lifejackets and fire erupted instantly. In almost no time the fire was out of control, spreading throughout the ship. Over 3,000 workmen had to be evacuated and sent ashore. Many were soon overcome by the brown smoke that seemed to be everywhere. Within an hour, the 1,028ft-long *Normandie* was burning from end to end. The brisk winter wind fanned the fire and smoke drifted in a south-easterly direction directly over midtown Manhattan. It created an orange-coloured cloud. Fire trucks on land and fireboats in the Hudson arrived quickly and promptly poured tons of water on to the burning ship. Soon, snapping her mooring lines and yanking the gangways from position, the giant liner began to shift to port. It appeared that *Normandie* was burning to death. Yourkevitch appeared and all but begged the navy to let him aboard to open the sea cocks and allow the ship to settle upright on the Hudson River muds. Sadly, he was brushed aside, sent away, a victim of military bureaucracy. By late afternoon, navy officials had announced that the fire damage was 'light'.

But the listing, top-heavy *Normandie* had other problems. As the Hudson River tides changed, she would rise, possibly lose her already fragile stability and then capsize. Tugs tried to push the scorched ship into the side of Pier 88 to reduce the chance of capsizing. Meanwhile, several reporters with cameras were allowed aboard to record the horrific interior damage. But there was still great uncertainty.

Just after midnight, on 10 February, all remaining hands were ordered off the ship. Her list had increased – she might capsize. Shortly afterwards,

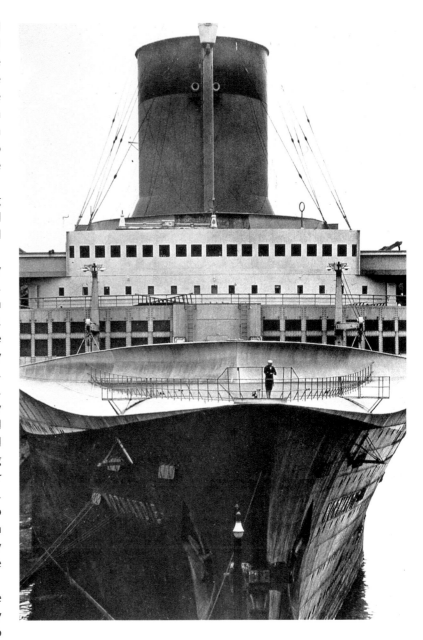

Above: Almost forlorn, the giant *Normandie* seems lifeless at her West Side berth. (Frank O. Braynard Collection)

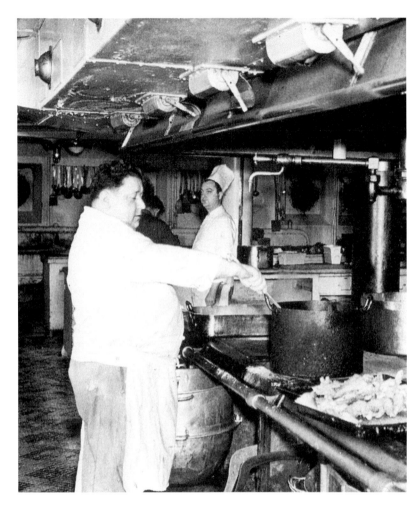

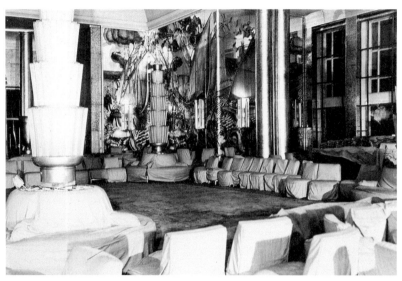

Left: A small crew of just over 100 looked after the French flagship and even did their own cooking. (Cronican-Arroyo Collection)

Below: The grand salon was dark, silent and the furniture overlaid with protective covers. (Cronican-Arroyo Collection)

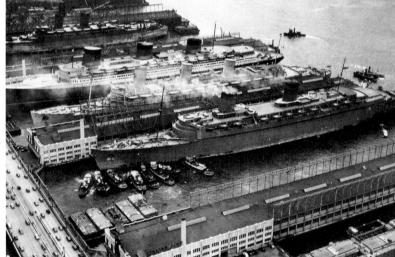

tugs and fireboats were ordered away from the slip, fearful they would be crushed. Exactly twelve hours after the start of the fire, at 02.37, in the darkness of that bitterly cold early morning, Normandie rolled over on to her side into the ice-filled waters of the river. Steam poured from her as the still-hot steel met with the chilled waters. Some reported hearing a great hiss. 'It was like the final breaths of a great, mortally wounded dragon,' said one onlooker.

A cartoon in a New York City newspaper summed up the mood of that disastrous week: it portrayed the Statue of Liberty in tears.

Naval architect Bill Deibert was among those deeply saddened by the premature end of the great Normandie. He commented:

Above: The brand-new Queen Elizabeth joins Queen Mary, Normandie and Mauretania in March 1940. (James Sesta Collection)

It was an unfortunate accident caused by carelessness, a tight schedule and a rush towards completion as a troop ship. There were, of course, many contributing factors. Fire watch and fire procedure/precautions were not being followed to the letter. Also, there were the highly combustible kapok lifejackets, soaked in oil but not covered. They were piled very close to where the cutting torch was being used. Then the ship's own sophisticated Fire Control Monitoring System was being disconnected at the time of the fire. There were too few fire buckets scattered about the ship and the fire hoses that were available had insufficient water pressure. Later, as the fire progressed, the additional fire hoses brought aboard by the New York City Fire Department had US-sized hose attachments, which did not fit the French metric water mains for proper connections. Then there were too few phones on board that were connected to shore to request help at the start of the blaze. The dedicated, very knowledgeable, but minimal French crew, which had been the skeleton crew that regularly checked the ship, were dismissed and sent ashore in favour of US Coast Guard and Navy personnel who were not familiar with the huge *Normandie*. The French crew were sent ashore supposedly for security reasons, suspected they might have allegiance to Nazi Germany and so be involved in the start of the blaze. The Navy's refusal to accept assistance from the ship's designer, who knew the vessel intimately and suggested flooding her and thereby keeping her upright, was another great error. Then there was the lack of coordination between the Navy and the New York City Fire Department. There was a question of who was in charge and so precious time was wasted. It would seem that the only positive point was that the capsized *Normandie* was used as an important Navy dive training and salvage school. This was very crucial in the early years of the War and much knowledge was gathered from the ruined *Normandie*.

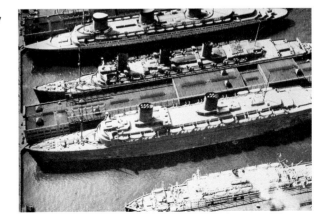

Comparisons: *Normandie* and the slightly larger *Queen Elizabeth* in the autumn of 1940. (Frank O. Braynard Collection)

The late Frank Braynard recalled that dramatic afternoon of 9 February 1942:

I was a student at Columbia University at the time and working on my PhD when I decided to impulsively cut classes and go downtown to see a movie. I saw a silly movie, as I recall, but when I came out of the theatre on 42nd Street, the sky above was all brown, a light brown actually. Smoke hung everywhere. I knew something was happening and made my way over to the West Side. I couldn't even get close, but just hung around for hours. It was terrible and later I interviewed Vladimir Yourkevitch, who told me that he tried to get US Navy permission to board the ship and open the sea cocks. Had this been done, the great

Three giants! *Normandie*, *Queen Mary* and *Queen Elizabeth* were the largest, longest and fastest liners of their time. (Author's Collection)

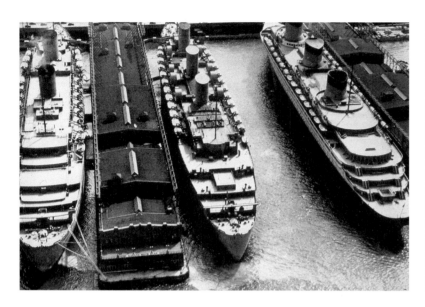

Another view of the three ships, called 'the monsters' by New York dockers. (Author's Collection)

After being seized by US authorities in December 1941, *Normandie*'s name is changed to USS *Lafayette*. (Cronican-Arroyo Collection)

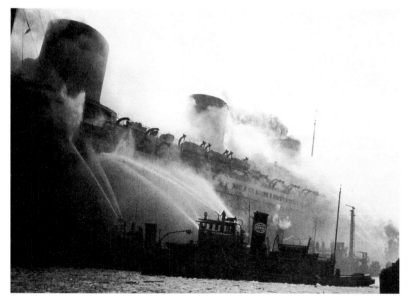

Fire erupts on the cold afternoon of 9 February 1942. (James Sesta Collection)

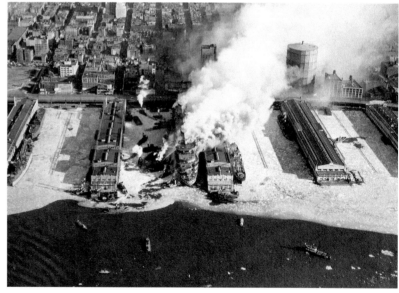

Smoke pours from the burning liner. (Cronican-Arroyo Collection)

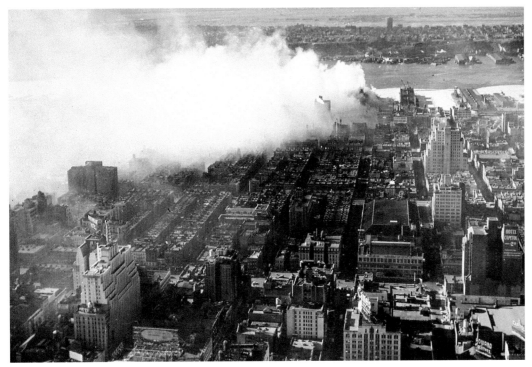

Fanned by winter winds, the orange-brown smoke drifts across midtown Manhattan. (Cronican-Arroyo Collection)

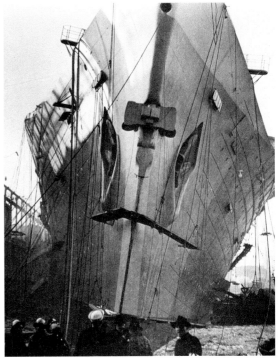

A view from the street: *Normandie* cants to port. (James Sesta Collection)

liner would not have capsized. The Commander of the Third Naval District who was in charge just brushed Yourkevitch aside with a brisk: 'This is the Navy's job!'

Pine Hodges agreed:

The tragic fire was an event which should not have happened, given proper working conditions and preparation for such a contingency. The Navy, in its haste to convert the liner, disabled her original French fire station on board, without completing an alternate during the conversion. A direct telegraph line to a nearby New York City firehouse was not connected either. Then it was found that the French hose fittings throughout the ship would not interchange with standard-issue American hoses of the local fire department. As John Maxtone-Graham has noted, the sequence of events that day on the *Normandie* took on

the dynamics of a 'Marx Brothers comedy turn' – but with a most tragic outcome. Had the four lighting pylons in her main lounge been left in place that day, none of the events of February 9th would have occurred. It was this rather 'nuisance job' of removing those steel pylons to make more space in the room, coupled with the careless, haphazard stacking of kapok lifebelts within the work area where heat and sparks were present, which altogether doomed the great ship.

To make matters worse, Vladimir Yourkevitch was right at hand if needed to open up the *Normandie*'s sea cocks so that the ship could settle on an even keel, thus making her easy to pump out. Had Yourkevitch been allowed to board and the great *Normandie* spared from capsizing, it is most likely that she, in conjunction with the two great Cunard Queens, would have taken even more months off World War II. The huge numbers of troops transported by these three giants would have been extraordinary. Furthermore, the *Normandie* was the

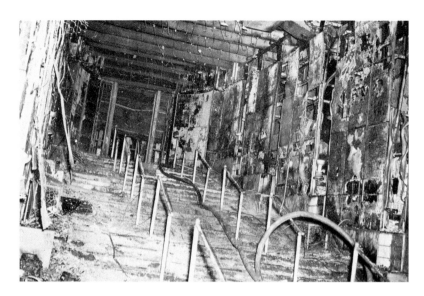

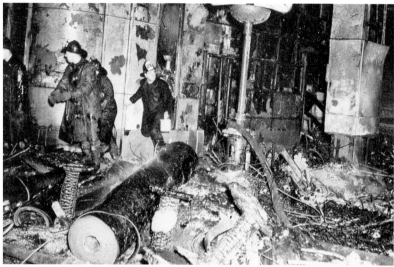

Photographers were allowed aboard by evening and recorded the scorched interiors. (Author's Collection)

Firefighters work through the smouldering rubble. (Author's Collection)

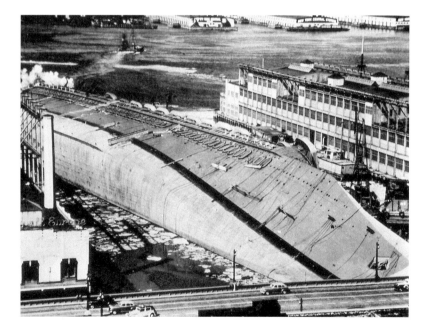

By the next day, 10 February, *Normandie* was on her side. (Cronican-Arroyo Collection)

only large ship apart from the Queens which could outrun German submarines without escorts, if needed.

Jack Watson was a newspaper reporter who went to West 48th Street and the Hudson River to view the ship. He waited until well after midnight:

> We stood and waited and froze. With barricades of soldiers, we were kept two blocks from the ship. But at about 02.30 in the dark of early morning, a great sound – a big swish actually – filled the otherwise quiet setting. The soldiers turned and some began to walk towards the river. This left openings for members of the press like me to get through. Finally, I saw the ship on its side – a huge, dead monster. She was still creaking, even moaning. Streams of smoke and the hissing of steam rose in the cold night sky as the hot steel hit the frozen waters. It was an incredible sight! It was also a very emotional one!

Steven Winograd added: 'Without question, the single biggest mistake after the fire started was not to let Vladimir Yourkevitch on board, who knew exactly what to do. [Had they] allowed her to sink in an upright position … she could have been salvaged, repaired and returned to service. It must have been heart-breaking for him.'

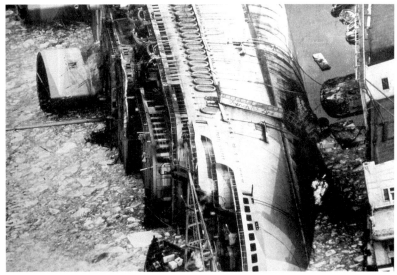

Seen from above, *Normandie*'s wreckage is clustered in ice. (Frank O. Braynard Collection)

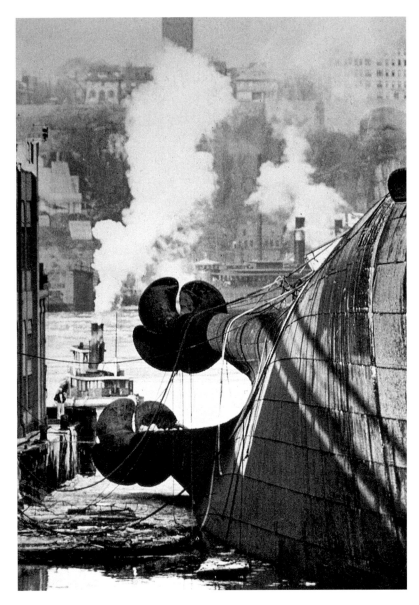

Grotesquely, *Normandie*'s starboard props protrude above the river waters. (Frank O. Braynard Collection)

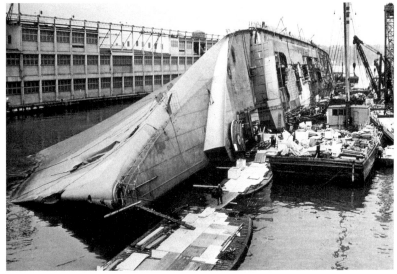

Partly cut down (with her upper decks and funnels already removed), the slow salvage of *Normandie* begins. (Cronican-Arroyo Collection)

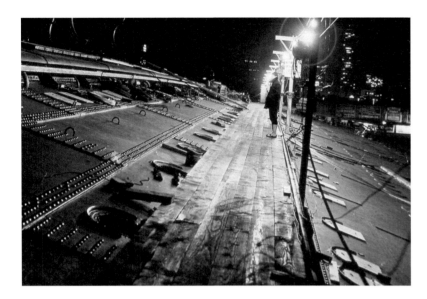

Night-time duty – a lone sailor stands watch along the starboard side of the capsized ship. (Cronican-Arroyo Collection)

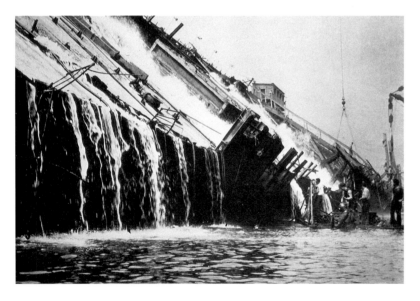

Pumping Hudson River water out of the ship has begun. (Cronican-Arroyo Collection)

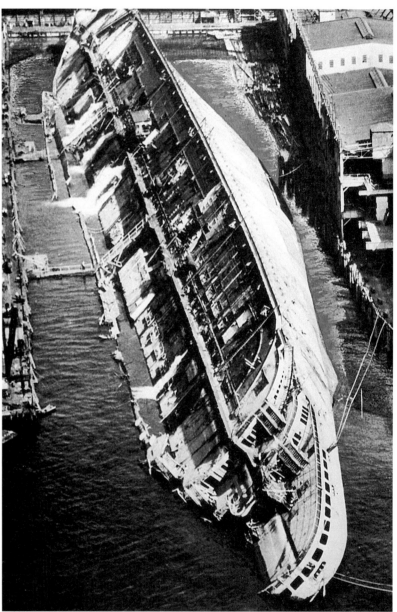

Part of Pier 88 had to be temporarily demolished (on the far right) to raise the liner properly. (James Sesta Collection)

Richard Morse is a New York-based ship enthusiast. He recalled:

It was a blustery Lincoln's Birthday, February 12th [1942], when I stood on the corner of West 49th Street and 12th Avenue, viewing one of the most tragic sights ever: the burnt-out, capsized wreckage of the grandest liner ever built. She had been done to death by catastrophic carelessness and monumental stupidity. Here was the absolute high point of marine architecture, lying there like some dead whale, totally helpless and useless. I began to cry as I thought back to happier times, seeing her in port, touring her extraordinary interiors. Here was an era destroyed within one ship. Farewell, thou goddess!

Rumours spilled out almost immediately. The most prominent was that Nazi agents had sabotaged her. Another was that the Mafia was involved.

Following an exhibition held in 1999 on Art Deco style and development, London's Victoria & Albert Museum said the deco age, which began in 1925 in Paris, actually ended seventeen years later with the burning of *Normandie*. They concluded: 'The party was over!'

At first, the US Navy felt confident that *Normandie* could be salvaged, repaired and – although much delayed – made ready for duties serving the Allied cause. But within days, inspections revealed that she was ruined; that she might even be scrapped where she lay. Quickly, crews with barges and floating cranes were brought in to cut away the three funnels, masts and parts of the upper decks. Removing these, it was felt, would increase her buoyancy. But she was 'locked' by a bed of rock at the pier's inner end and, while time-consuming and costly, she would have to be pumped out and then only slowly and carefully righted. Complicating matters were two small fires in March and May 1942, caused by welders' torches. US Navy divers were brought in, a training school was created and the entire process ranked as the greatest salvage job ever (and one costing a staggering $5 million). The hull of *Normandie* was not fully righted until 15 September 1943, some eighteen months after the fatal fire.

Newspapers again featured stories of repairing and then rebuilding *Normandie*, most likely as a troopship, but also with creative ideas as a large aircraft carrier. On 3 November, under the care of a dozen tugs, the hull was moved from Pier 88. It was her first movement in over four years, since arriving on that August afternoon in 1939. She was taken to the 1,100ft-long graving dock at the Navy Annex at Bayonne, New Jersey, for underwater hull inspection. Afterwards, tugs moved her across the Upper Bay to the 1,700ft-long Columbia Street Pier in Brooklyn. She waited there for eighteen months, barely noticed, until the war in Europe ended in May 1945. A month later, the US Maritime Commission, who now looked after the vessel, declared her surplus to American needs and at first offered to resell her to the French. The offer was politely but firmly declined. 'Mostly, we need food, and also supplies and tools for rebuilding – and for that we need freighters not liners,' was one comment from Paris.

Fittings from *Normandie*, which had mostly been removed in the weeks just prior to her demise, had been auctioned off by the US government in six public sales in 1942 and 1943 (and then again in 1945–46). Everything, it seems, went for bargain prices. Values were different: there was little or no money available during and immediately after the war for collecting furnishings. Art Deco was not yet seen as a collectible style and many serious collectors and buyers saw furnishings and furniture from *Normandie* as somewhat substandard to more valuable antiques in the category of 'commercial, hotel-like fittings'. Consequently, four charming wooden hobbyhorses went for $30 apiece, while the distinctive life preservers – all 8,534 of them – fetched $310. Later, in the 1950s, 150 glass panels were sold for a scant $1,500. These days, some grace the Metropolitan Museum and eight are in the Forbes collection, also in Manhattan. Some items from the liner taken ashore in January 1942 were warehoused in and around New York City and then, as one art dealer said, 'simply vanished'. A large group of chairs found its way to a basement in Connecticut, but was destroyed in a flood. Other items have reappeared after long stays in obscure warehouses, suburban attics and even garages. Beginning in the 1970s, as interest in the Art Deco period developed and then skyrocketed, searches turned more serious and prices began to soar. 'Items from the *Normandie* became the "hot ticket",' said Lewis Gordon. 'Friends of mine paid thousands for a few pieces of Grand Salon furniture.'

A good number of items were returned to the French, however, and briefly warehoused in the late 1940s. These were used in the post-war restoration of *Île de France* and *Liberté*. For example, the middle section of the huge Aubusson carpet that was in *Normandie*'s grand salon reappeared, in 1949, in the cabin-class drawing room aboard the re-commissioned *Île de France*. Panels from *Normandie*'s smoking room found their way into the grand salon aboard *Île de France*, as did glass panels from the grand lounge, which appeared in *Île de France*'s smoking room.

The larger CGT flagship *Liberté* was given even more items from *Normandie*. The first-class grand salon aboard the ex-German *Liberté* appeared much more French and so included items from *Normandie*. Some saw it as an attempt at recreation, even duplication. Panels from *Normandie*'s smoking room reappeared in *Liberté*'s smoking room, for example. Elsewhere, chairs, tables, smaller carpets, china, silver and even

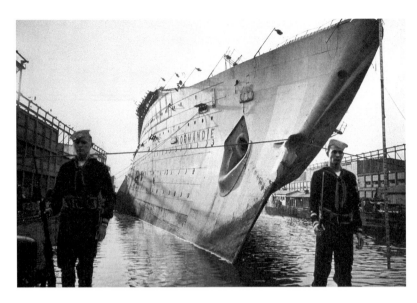

By the summer of 1943, the ship has been gradually righted. (Cronican-Arroyo Collection)

linens from *Normandie* were used aboard both the post-war *Île de France* and *Liberté*.

Many other items were kept in American hands and sold off, mostly after the war ended, in 1945–46. The La Normandie statue from the smoking room and a set of bronze doors, for example, were bought by a Brooklyn priest. Monsignor Mansour Stephen and his congregation had just acquired a church in Brooklyn Heights, at Remsen and Henry streets. That location was within walking distance across the East River from Lower Manhattan and an equally short distance from the Columbia Street pier where *Normandie*'s salvaged hull spent three years (1943–46). Originally called the Church of the Pilgrims, it was renamed Our Lady of Lebanon Church and Mgr Stephen was anxious to glorify it, 'to fill it with beautiful things', he said. The bronze doors, which had opened into the first-class dining room, were purchased for $1,025. Another purchase followed, this time for another set of doors bearing ten bronze medallions. Stephen spent less this time – $975 in all. La Normandie was sold again, this time for use in the Fontainebleu Hotel in Miami Beach, Florida. It remained there for some thirty-five years before being sold, in 2001, to Celebrity Cruises for use aboard their then-new 90,000grt cruise ship *Celebrity Summit*. The ship was fitted with a special grill room that had a *Normandie* theme.

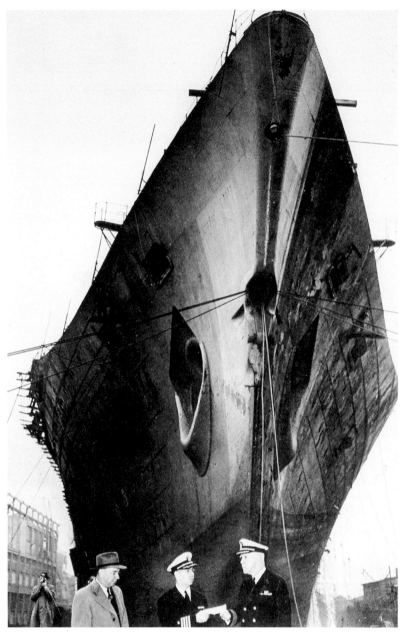

The ship is passed over for further evaluation and possible wartime use. (Cronican-Arroyo Collection)

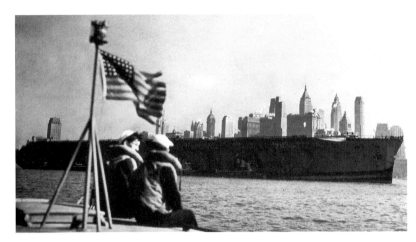

Left: The vast, lifeless hull is towed downriver, off Lower Manhattan, in November 1943. (Cronican-Arroyo Collection)

Centre left: A striking view of the salvaged *Normandie* as she reaches the Upper Bay for positioning into the graving dock at Bayonne, New Jersey. (Frank O. Braynard Collection)

Bottom left: The hull was badly scarred from Hudson River muds. (Frank O. Braynard Collection)

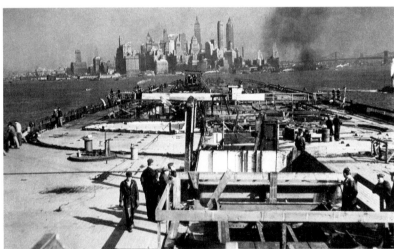

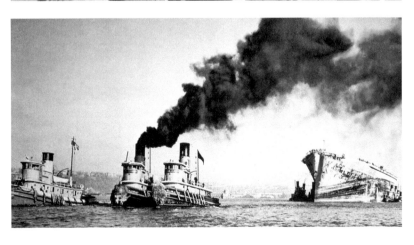

The statue was intended to be used there, but was actually mismeasured and could not be included. Instead, it found itself placed at the centre of the 1,900-passenger ship's main restaurant. Another statue, La Paix, which had stood in *Normandie*'s grand dining room, was sold and ended up in the Pinelawn Memorial Park in Farmingdale on Long Island, New York. The double doors that had separated *Normandie*'s grand lounge and smoking room were later installed in a fancy Manhattan restaurant, Mr Chow's. The Gaveau piano from the ship's sumptuous Deauville Suite was auctioned off in December 1942 for $200. It sold again sixty years later for $75,000.

When *Île de France* and *Liberté* were retired and then scrapped, furnishings and other items that had been previously aboard *Normandie* were sold off – to hotels, restaurants, and small armies of private art and memorabilia dealers as well as collectors. A sizeable auction was staged in Monte Carlo in 1981 and included numerous items originally from *Normandie*.

Apart from furniture, the 620lb steam whistle from *Normandie*'s forward funnel found its way, in 1946, to the Bethlehem Steel Company plant in Bethlehem, Pennsylvania. Calling men to work as well as sending them home for decades, it was returned to New York archivists when the steel plant closed. It produced a commemorative blast near the South Street Seaport in June 1985 for the 50th anniversary of the ship's maiden voyage. It was put to use again, in June 2010, also at the Seaport, for the 75th anniversary.

Declined by the French, would the cavernous hull of *Normandie* be kept in mothball reserve by the US government to await later use by the military, to perhaps be rebuilt as an aircraft carrier? No, that was never a likely possibility. The US government had an abundance of ships after the

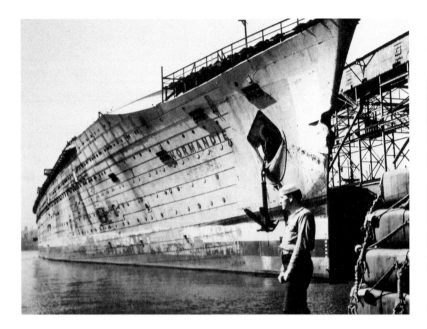

Left: Laid up, idle and all but useless, *Normandie* waits at a Columbia Street pier, Brooklyn, in 1945. (Frank O. Braynard Collection)

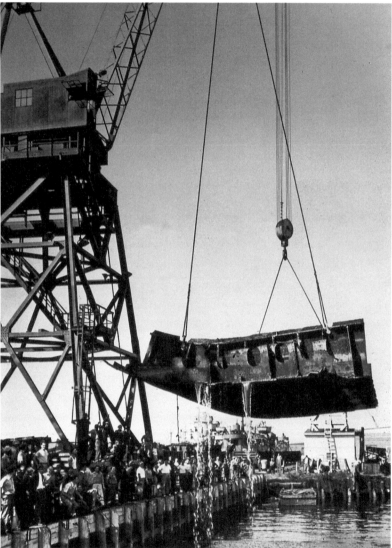

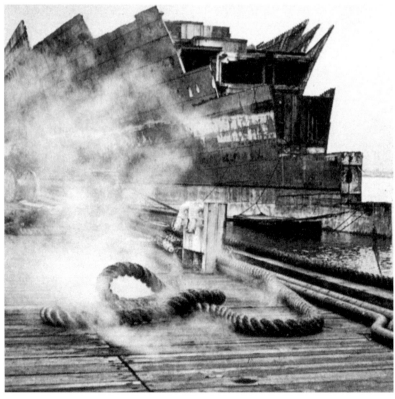

Above: Last rites! The final piece of *Normandie* is lifted from the water in October 1947. (Frank O. Braynard Collection)

Left: Demolition! The final remains of the ship as seen in summer 1947 at Port Newark. (Frank O. Braynard Collection)

war, both military and commercial. In reality, there was very little hope for the 11-year-old vessel. She soon went to government auction and, on 3 October 1946, was sold to the New York-based Lipsett Corporation for scrapping at $3.80 a ton or $161,800. In the quiet of Thanksgiving Day, 28 November 1946, the scarred hull of *Normandie* was towed from Brooklyn (by twelve tugs) across New York's Lower Bay, along the narrow Kill van Kull to Port Newark, New Jersey. The name Lipsett was painted along her sides and across the top deck. It was indeed a sad sight – the initial death rites of an ocean queen. Demolition began immediately.

Deeply disappointed, Vladimir Yourkevitch remained intensely loyal to his ship, his finest design. Even in 1947, when scrapping had already begun, he was drawing a reduced, twin-funnel *Normandie*. It was such a convincing idea that the French sent a marine representative from Paris to New York who responded with enthusiastic reports. Yourkevitch's sketches showed a new superstructure built on the existing hull and using the engines that were not submerged. The hull would be cut in two, a section removed and the two remaining sections rejoined in dry dock. The ship would be reduced in size from 1,028ft to 808ft, from 83,000 to approximately 50,000 tons, and her service speed reduced to a maximum of 28 knots. Her four screws would be reduced to two, her name would be changed and her rebuilt accommodations (for 1,500 passengers in two classes instead of three) would be more comfortable than luxurious. Hull and engine work, estimated Yourkevitch, would be done in an American shipyard, while the interior decoration would be done in a French yard. He estimated the total cost to be $8 million. Of course, the French would first have to purchase the ship from the US Maritime Commission, which held title after the salvage. Interest was lacking, however. The French did not have the monies either

to purchase the ship or pay for a conversion, and by then they had been given the ex-German *Europa* as reparations, which would be extensively rebuilt as the new French Line flagship *Liberté*, an adequate and suitable replacement, they felt, for *Normandie*.

Normandie made one last move: on 26 July 1947 her remaining hull was shifted by tugs from the outer side of the naval depot berth in Port Newark, where she was being scrapped, to the opposite, inner side. This was done to allow dredging in Port Newark channel.

The last piece of *Normandie*, a 75-ton section of the boiler room, was lifted ashore on 7 October 1947. It was placed on a rail car and sent off to an eastern Pennsylvania steel mill. Altogether, the remains of the liner had yielded 40,000 tons of steel and 10,000 tons of brass, copper and other metals.

But what if *Normandie* had survived – had been a valiant, successful wartime trooper, later restored and returned to French Line Atlantic service? It is an often asked question, a matter of considerable discussion

and theory. And then, in the end, what would have been her final fate? Frank Trumbour stated:

I believe she would have enjoyed great success after the Second World War, in the late 1940s and during the 1950s. She would have been as popular or maybe even more so as the two Cunard Queens. But then she too would have been 'done in' by the jets in the 1960s. There would not have been a need for, say, the *Liberté*, the former German *Europa*, and then there might not have been a new *France* [completed in 1962], of course. In the very end, given the pride that the French had in the *Normandie*, she may well have been preserved.

Pine Hodges commented:

The *Normandie* would likely have been refitted to resume her work on the Atlantic Ferry following the war, although it has been speculated that some of her original finery would not have been reinstalled. Everything valuable had been removed in New York, and doubtless some of it would have been lost, damaged or sold. The original French glass-makers would have replaced most missing glass fittings, and fabrics would have been re-woven, but art deco as a style would have already been regarded as 'passé'. As a result, there would have been a tendency for the CGT to order more 'modern' materials in place of the originals. John Maxtone-Graham has noted that the Dupas glass panels likely would not have been put back in the lounge, and that veneer-faced plywood panelling in the adjacent smoking room would have replaced the fine leather which originally covered its walls. Furthermore, the French did not have all the resources after the war to return their flagship to its original glory.

The *Normandie*, like the Cunard Queens, would most likely have survived into the late 1960s, until troublesome mechanical problems beset the liner. Then the *Normandie* would have been retired like the fabled Cunarders, and hopefully a French port such as Honfleur or Cherbourg or Cannes on the Riviera, would have preserved her as a combination hotel, convention centre, even museum. Of course, the scrap merchants would have been 'all over' the *Normandie*, so it would have been a close contest at the very least.

By the late 1960s there was renewed interest in the Art Deco/Moderne style, so it might have been quite easy to restore some of *Normandie*'s original interior features, on the premise that her basic steel structure was intact and there was, and still is, ample documentation of her 'as built' interior condition. Also, such a collection of Art Deco design features, built in such a large quantity, could not have been found in a single place anywhere else in the world, be it on land or at sea. The next largest maritime collection of Art Deco features, as some of us already know, comes from *Normandie*'s rival from 'across the Channel', *Queen Mary*.

Steven Winograd added: 'In the 1950s, in the final heyday of Atlantic liners, the *Normandie* would have been the greatest star, even surpassing the Cunard Queens. She herself would have been more luxurious and more popular than ever, and a great post-war ambassador for France. She would have been a great tonic as well. Most likely, she would have softened the blow of the loss of French power and prestige.'

Bill Deibert feels that *Normandie* would have survived. He said:

She was, after all, already a floating museum and an expression of an era in transition – from the traditional Old World to the modern. In fact, she was really 'tomorrow', just as the 1939–40 World's Fair had the 'World of Tomorrow'. The *Normandie* was built at a time when the world was full of novel and innovative superlatives – the tallest deco buildings, the biggest theatres, the largest hotels and the fastest, longest liners. It was also an age of luxury travel – in liners, trains, even great airships. It was an age in which even the likes of household items – kitchen mixers, can openers, refrigerators, steam irons and vacuum cleaners – were becoming 'modern' and were 'streamlined'. Everything began to be clean and uncluttered. The *Normandie* would have been saved, I strongly believe, because she was more than a great liner. She was a statement of design, art, innovation, a grand representative of a sensational era, the 1930s. Inspired and created by the French, always masters of great design, the *Normandie* was not afraid to be radically different from the very beginning. She was a great divide in the definition of luxury, power and beauty, culture and sophistication.

POST-WAR, POST-NORMANDIE

CGT, the French Line, was all but devastated by the Second World War. Their grand fleet of the 1930s was but a memory. While *Île de France* survived, both *Lafayette* and *Paris* were lost in pier-side fires at Le Havre in the late 1930s, *Champlain* was sunk in 1940, the exceptional *Normandie* had been lost at New York in 1942, of course, and even the smallish *De Grasse* was nearly a complete loss – she was sunk by the Nazis in the summer of 1944 and was only slowly being salvaged a year later.

CGT's Paris office, it seems, had to reassemble the pieces of a large, disjointed, much reduced puzzle. In May 1945, just weeks after VE Day, the 7,700-ton passenger-cargo ship *Oregon* resumed its Le Havre–New York sailings. Built in 1929 to carry thirty-eight passengers, she was refitted to carry as many as seventy-six across the Atlantic. The berths in each cabin had been purposely doubled. A year later a sister ship, *Wisconsin*, joined her on the New York run. What a great difference from, say, 1939 and crossings aboard *Normandie*! There were also some charter sailings by other French passenger ships, all still in wartime mode, namely *Colombie*, *Athos II*, *Indochinois* and *Marechal Joffre*. The larger *Île de France* resumed service as well, but as an austerity ship, carrying passengers, immigrants, displaced persons and returning troops. She was not restored until the summer of 1949.

The salvaged, reconditioned *De Grasse*, with a rather meagre capacity for 720 passengers in two classes, actually restarted the French Line luxury service in July 1947. She was, of course, immediately popular and booked to capacity on almost all sailings. But again, what an exceptional contrast to those glorious, glittering years before the war when the 574ft-long *De Grasse* sailed in company with *Normandie*, *Île de France*, *Paris*, *Champlain* and *Lafayette*.

Marie Louise Schaff remembered: 'On my first trip to Europe in 1951, I was one of many students in the lower deck tourist-class quarters aboard the fabulous *Île de France*. Almost all of us were bound for a year's study in Paris. The week-long crossing was filled with excitement and anticipation.' She recalled that long-ago August voyage some forty years later as we lunched together during a different passage, a transatlantic cruise on the all-first-class *Crystal Harmony*. She continued:

Most of us were art students, but one young man was especially taken by the superb food – its flawless creation and superb preparation – that was the hallmark of the French Line, even in inexpensive tourist class. The dinner menu, as I remember it, included the likes of *Bisk of Lobster Morbihannaise*, *Supreme of Turbot Étuvé* and *Truffled Chalosse Goose Liver*. Even the breakfasts were a treat. I remember Skate in Butter Sauce at 8 in the morning! Before we reached Le Havre, that young man decided to abandon his art studies and concentrate on food and cooking.

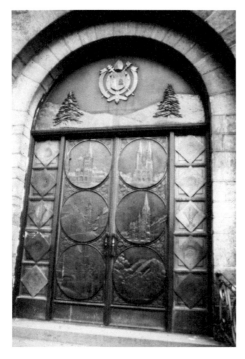

The bronze doors at Our Lady of Lebanon in Brooklyn Heights, New York. (Author's Collection)

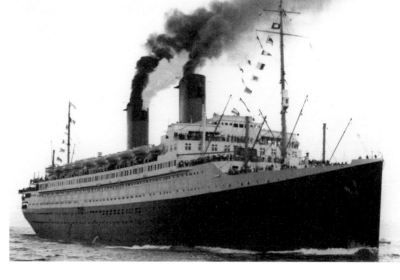

Île de France returning to New York for the first time since her post-Second World War refit, summer 1949. (Moran Towing & Transportation Co.)

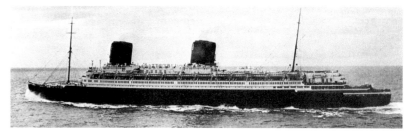

Liberté at sea, as seen from *Île de France*. (Author's Collection)

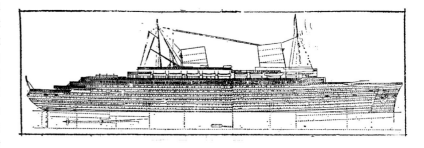

A rare sketch by Vladimir Yourkevitch of a smaller, shortened, totally rebuilt *Normandie* as proposed to the French Line in 1946–47. (Author's Collection)

His name was Craig Claiborne and, of course, he eventually became the food editor of the *New York Times*. For him, it all started on the summer voyage aboard the *Île de France*.

Unquestionably, the *Île* – as she was nicknamed – was one of the greatest and grandest of all Atlantic ocean liners. She typified the term 'ocean greyhound'. Built in 1927, and remeasured at just over 43,000 tons, she was not one of the largest or fastest liners, but certainly still one of the best-decorated, best-served and best-fed ships of all times. She was a ship of Aubusson carpets and Lalique lamps, lavish lounges, a restaurant likened to a Greek temple and a chapel so ornate and detailed that it included fourteen pillars. She was high Art Deco on the high seas! She was definitely a ship of white pianos and glossy black tile floors, one described years later as 'early Ginger Rogers'. Her staff was prized, handpicked and envied – from suave captains to those red-suited bellboys in little pillbox hats. And, as mentioned, her kitchens were unsurpassable. The French Line publicity boasted that more seagulls followed the *Île* than any other liner because the scraps were better! She even had a certain ambience, coined as 'the cheeriest way to cross the Atlantic'.

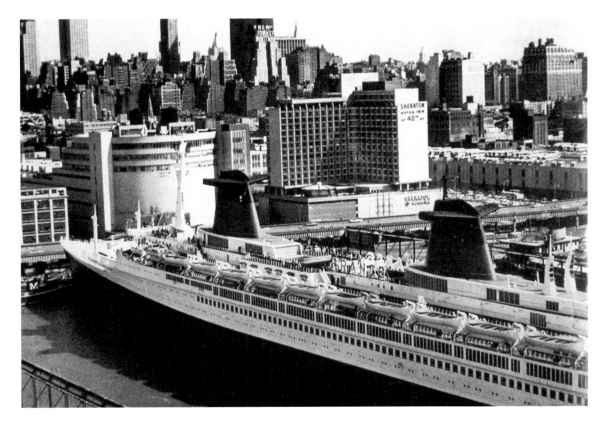

there had been some thought of taking the 1939-built, 29,000grt *Pasteur*, just released from French government Indochinese trooping duties, and making her over as a luxurious Atlantic liner. Then there were thoughts of building a pair of 35,000-ton liners. But there came rumours, whispers even, of Cunard planning a 75,000-ton replacement for their ageing *Queen Mary*. The old competitive spirit was revived. And then France itself was caught in political turmoil, in dwindling international prestige and might over yet another withdrawing colony, Algeria. The government felt that a new French super liner might just be the right tonic. So, like *Normandie* and others before her, the new ship would be a national morale builder, a showcase of French technology, design and decor, and a great roving ambassador. She, too, reported a Paris minister, would highlight the 'brilliance of France'. She would surpass British ships, challenge Cunard and singlehandedly replace the two older French liners. Construction began in September 1957 and the 66,348grt, 1,944-passenger *France* was commissioned in the winter of 1962. Most notably, at 1,035ft from stem to stern, she was the longest liner yet built.

While popular, prestigious and well publicised, the stunning *France* sailed for only twelve years, until September 1974, when CGT pulled out of Atlantic liner service altogether. It was simply all too expensive with fewer and fewer passengers. The airlines had won out. Thereafter, CGT concentrated mostly on cargo shipping. The redundant *France* was sold in 1979 to become *Norway* for Norwegian Caribbean Lines, the world's first mega cruise liner, before being decommissioned in 2003 and ending up in the hands of Indian scrappers six years later.

From 1946, Martha Levin was employed at the French National Tourist Office. Their Rockefeller Center offices were just a floor above the French Line's uptown Manhattan headquarters. She stated:

In the 1950s, I sailed on the *Liberté* and the *Île de France*. The French always did ships so exquisitely – grand staircases and public rooms and superb food and wonderful service. Years later, I flew on the Concorde, then a new dimension in travel. It was the modern version of the *Normandie*. It was great technology plus luxury and comfort. Just as on board the French Line, there was non-stop gourmet food plus, of course, endless service. We also did a cruise on the clubby, six-star-rated *Silver Cloud* of Silversea Cruises. It too was so deluxe, so personalised. It was modern luxury, perhaps the *Normandie* of this age.

In the 1950s the French Line again had its chic, great style and popularity. But the future was in question. Both the *Île* and *Liberté* were growing old. The *Île* would go first, in 1958; *Liberté* by the end of 1961. Briefly,

REFLECTIONS, SALES &
DECODENCE

Weeds were growing out of the railway tracks that once welcomed the famed 'boat trains' coming up from Paris. Terminal buildings and adjacent warehouses were shut and lifeless. The vast French Line passenger terminal was no more. I was visiting during a European cruise, aboard the luxurious *Crystal Harmony*. Le Havre was a port of call. The date was August 1993 and the setting was silent, nostalgic, filled with a sort of maritime melancholy. It was here that *Normandie* had berthed, *Paris* had sadly burned and where I had arrived from New York in July 1973 aboard *France*.

I had no introductions, no maps or directions, but I had heard that the huge French Line archives had moved here from Paris. It was being stored while awaiting the organisation and then opening of a French ocean liner museum at Le Havre. Luckily, I came across a small group of model-makers (adding the finishing touches to a 6ft-long model of *Normandie*, no less) and they directed me to the former French Line warehouse (where company linens, for example, were once stored). Here was an Aladdin's cave of treasures: photos, brochures, menus, passenger lists, ships' logs, original artwork and selected furniture (at least one piece, it seemed, from each liner stretching back to the *France* of 1912). Each room or section was devoted to a different archive. Louis Rene Vien was then in charge and was most welcoming and helpful. He outlined the collection, explained parts of

it and enthusiastically shared in the future plans (the museum did not, alas, materialise). I especially recall large cupboards used for china, glassware and silver. It was thrilling to touch and handle pieces from *Normandie*. But most interesting to me was the vast collection of filing cabinets containing the seemingly limitless photographic archive, all of it neatly catalogued and organised. Photographs alone of *Normandie* filled several cabinets and could have filled several books on that illustrious ship. That afternoon visit was exceptional, the experience unforgettable.

Normandie has not only endured in books, articles, exhibitions and in several television documentaries (some of which include rare colour footage made on her final passage to New York in August 1939), but on 20 January 2007 she 'set sail' once again. Sixty-five years after her tragic end by fire in New York, the sumptuous *Normandie* lived on. On this January day the Ocean Liner Council of New York City's South Street Seaport Museum and the Steamship Historical Society of America's Long Island, New York chapter organised a full-day salute to the immortal French flagship. A sell-out, the programme was divided into three segments, each hosted by top collectors and experts on *Normandie*.

John Miottel of San Francisco, one of the foremost *Normandie* collectors in all North America, told of his superb collection in both word and film; New York-based Rory McEvoy, another first-class collector, showed a rare

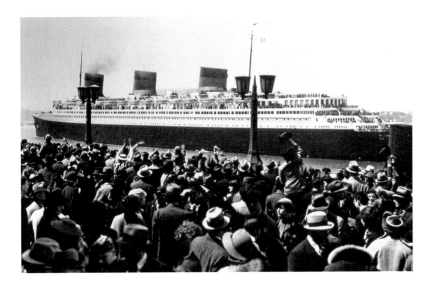

Seen from Pier 88, *Normandie* heads for Europe. (Cronican-Arroyo Collection)

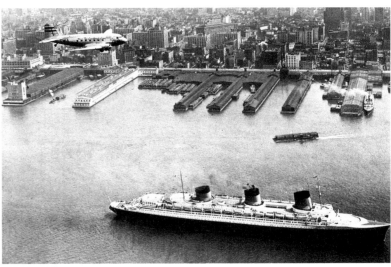

Novel arrangements: TWA offered convenient air connections from California to New York for *Normandie*'s departures. (Frank O. Braynard Collection)

film of the ship's Carnival-in-Rio cruise in 1938; and Mario Pulice, keeper of the finest *Normandie* collection in New York City, hosted a photographic tour of his vast holdings. Their collective passion extended to the guests, fellow *Normandie* buffs and fans of the great age of ocean liners. Richard Faber, one of the principal organisers of the occasion, said:

The week before, leading up to the *Normandie* event, was rather hectic, pulling the loose ends together. There were the guest lists, food orders, arrangements and much more. It was finally Saturday, the day of the programme and a day of brisk winter wind, but happily bright sunshine. It was perfect for the magnificent setting atop the Seamen's Church Institute Building just off South Street. Many of us were there bright and early. But soon the excitement began. The guests arrived, with many familiar faces among them and from as far off as California and two all the way from Britain. When the event was about to begin, I was actually amazed just how many ship enthusiasts were present. Never have I seen such a supportive turnout. Of course, the draw was the *Normandie*, that magical name. But it was also to hear and see three top *Normandie* collectors, all of whom are usually private people and tend not to want any publicity. When the time came for them to make their individual presentations, that big crowd was on the edge of their seats, listening

to every word. Occasionally, you could hear a sigh at seeing something particularly special. No one seemed anxious for the presentations or the day itself to end. They were eager for more. I can't recall seeing such enthusiasm. It was a great day, a tribute to the unending interest in the great *Normandie*. But it all ended too soon.

Months later, in June, at an ocean liner auction at Christie's, also in Manhattan, *Titanic* and *Normandie* were the big and steady sellers. Indeed, they tend to be the top sellers in liner collectibles. Frank Trumbour commented:

I think that both ships qualify as legends. Both ships were magnificent yet both ships were tragic. The *Titanic* represented a commentary on the Gilded Age – the extreme wealth and the extreme poverty. In the end, I think the *Titanic* stirs emotions about time/event in the not-too-distant past that is in the end very, very fascinating. The *Normandie*'s qualities as a legend speak for themselves. She had the most fabulous style … perhaps the largest as well as the most perfect collection of art deco ever assembled in one place. Her short career set in the high spirits of the 1930s, if you had the money that is, also adds to the cache. Because of the existence of so much of her interior appointments, one can 'buy' the

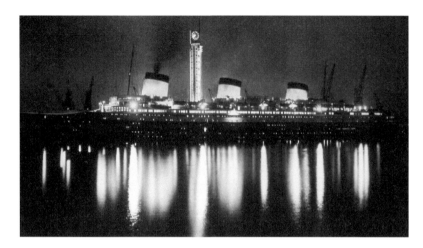

Left: Aglow and picturesque, *Normandie* at Le Havre. (Author's Collection)

Below: Gala day! Five Atlantic liners are gathered together in a scene from March 1937. *Europa* is at the top, followed by *Rex*, *Normandie*, *Georgic* and *Berengaria*. (James Sesta Collection).

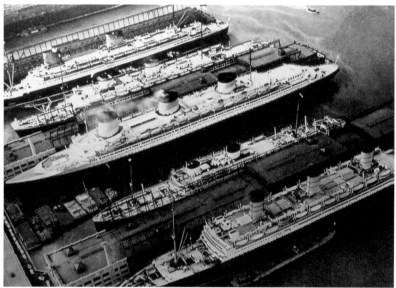

past and acquire the glamour. The *Normandie* differs from the *Titanic* in terms of legend because of the vivid memories of those great Hollywood musicals and the stars that appeared in them. Many of them actually sailed on board the *Normandie*. Royalty, as well, travelled aboard. So, you can get your hands around that 1930s chic that is almost impossible to grasp elsewhere. Additionally, since there were ordinary people who sailed her as well, an ordinary person today can envision himself or herself luxuriating aboard the French flagship. It is that inescapable allure of glamour that secures the *Normandie*'s place as a maritime legend.

Several months followed until, in November, three dozen fans of ships of all kinds gathered in a Manhattan restaurant. In a setting that was just a few blocks from Pier 88, the former French Line terminal, a formal tea party was arranged to celebrate the publication of yet another book, *Normandie* by John Maxtone-Graham. Some of the faithful had come to pay homage. Guests were anxious to see the new title, pour over the pages, and delight in the photographs and text. An ocean liner buff said: 'She was the best of all liners. There was nothing, absolutely nothing, quite like the *Normandie*!'

By the winter of 2010 I had been made Curator of Ocean Liner Studies at the South Street Seaport Museum. Together with Mary Pelzer, the Seaport's president, we discussed various options on how best to promote the museum's vast ocean liner collection, exhibit more items and generally spread the word about twentieth-century liner history. One idea was to create a major exhibit highlighting a particularly appealing ship. *Titanic*

Tendering in Southampton Water. (James Sesta Collection)

came readily to mind, but was quickly put aside as we realised that 2012 was the centennial of that ship's tragic sinking. *Normandie* was the second choice. Personally, I was intrigued and began gathering items from collectors not only in New York, but throughout the United States. I began with Mario Pulice and his extraordinary collection housed in his large apartment on the Upper West Side. He might loan an ashtray, maybe even a grand salon chair, I thought. A visit was soon arranged.

As always, Mario was charming, friendly and most welcoming. But then came his surprising, almost overwhelming offer: the museum could borrow his entire collection for a year, longer even. He could live without it, he said, and it would create the perfect opportunity to repaint his entire six-room apartment. I was elated – we had gained 99 per cent of the exhibition in one evening. Back at the Seaport we moved quickly, assembling a team, organising dates and openings, creating cases and display units and mountings. A first-class 'crew' was mobilised and together named the exhibition – *DecoDence: Legendary Interiors & Illustrious Travelers Aboard the SS Normandie*; or, more informally, *DecoDence*.

Mario Pulice noted:

I clearly remember the night back in early March 2009 when my dear friend Bill Miller rang me up and told me that South Street Seaport was mounting an exhibition on *Normandie*, scheduled to open in February of 2010. The exhibition at that point had no name, and was very much in the early planning stages: budgets were being discussed, collectors were being contacted, exhibit designers were submitting proposals, etc. I felt honoured and thrilled when Bill asked if he and some of the South Street officers could stop by my home and look at my collection of *Normandie* furniture and memorabilia, and discuss whether I would be interested in contributing to the exhibition.

The following week, Mary Pelzer, Carol Rauscher and Bill arrived promptly at 6 p.m. Quickly we got down to business. As every collector well knows, there is a great sense of pride and accomplishment one feels when you show your years of passionate and dedicated collecting to an admiring audience. Bill had of course seen everything before, but his enthusiasm and interest were as if he was viewing it all for the very first time.

The four of us later sat for a few minutes to discuss the exhibition. And then the question from Bill: Would I like to participate in the show? And which items would I feel comfortable loaning to South Street Seaport Museum? Without any hesitation I answered, 'Yes', and added, 'You can take all of it, if you'd like.' I don't think I'll ever forget the look on Bill's handsome face. And the South Street ladies seemed equally dumbstruck. They all exchanged glances, seemingly not sure what to say next. Finally Bill chimed up, 'All of it? But what will you do without all your furniture and artwork?' To which I responded, 'Well, I've been meaning to paint and redo the floors, so this will clear the place out and make all that a whole lot easier.'

Matters moved on quickly. Mario added:

On a dismal grey and snowy day in the following January, trucks arrived, my collection was wrapped up and carted away. I must say, however, it was a bit strange after the movers left. I realised, rather oddly, for the first time I had no dining room table or chairs, and wouldn't for at least the next eight months or so. That afternoon, I went across the street to Ace Hardware to purchase a couple of collapsible tray tables and two simple folding chairs. When I got back home with my purchases, I found that my two cats had gone absolutely berserk. They were running at full throttle from room to room, ecstatic not to have all that cumbersome furniture to navigate around. They could not have been happier!

The next month, I was invited to visit the gallery a few days before the intended gala opening party to see the exhibit. Upon entering, I was really taken aback at the amount of work that still needed to be done and the chaos of the space. I really did think that there was no possible way they could pull it all together on time. But to the staff of South Street Seaport's credit, all was finished precisely as scheduled.

I'm not sure exactly how to describe how I felt walking through the exhibit and viewing my collection in a completely different setting for the first time. It took me a while to take it all in. As I walked through the exhibit, it actually seemed like it was not my collection I was looking at. The exhibit designers had creatively made blow-ups of various rooms as backdrops to my furniture and artwork. The silverware was all meticulously polished and perfectly aligned in display cases. Descriptive wall lettering and signage led you from item to item. And for ambience, there was a sensational colour period promotional movie of *Normandie* looping in one of the alcoves. I think the detail that caught my attention most was a soundtrack that constantly played in *Normandie*'s dining room exhibit area, which looped the sounds of clinking china and glassware and the faint hint of dinner conversation in the background. How brilliant! It was much like looking at my things for the first time again. I think some collectors might agree that it's sometimes easy to forget what we are fortunate to have amassed and have in our possession.

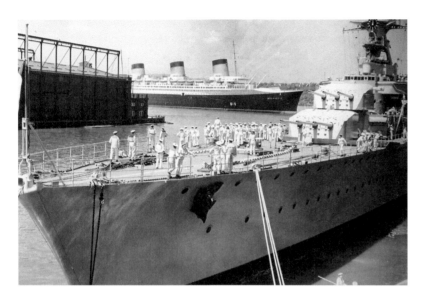

A French warship visiting as *Normandie* makes an afternoon arrival. (Cronican-Arroyo Collection)

Over the next year of the exhibit's term, I visited about half a dozen times with friends and family, and proudly escorted them through the show. I would always take the time to watch and listen to other exhibit-goers looking at the objects and furnishings. Of course, they hadn't a clue who I was. I'm sure some of them must have thought, 'Who's that guy over there and what's he smiling so much about?'

Bill and the people of South Street could not have been more gracious in their appreciation of my loan. It was my total pleasure, and it was an event I will always be very proud and honoured to have contributed to.

A few weeks ago, Bill rang me up and told me about finishing up this book, and asked if I would like to contribute something to it. I again didn't hesitate and said, 'Yes, of course!' Absolutely anything for you, dear Bill. In closing, I cannot thank him enough for so many things: his loyal friendship, generosity, charm, enthusiasm and his wonderful writing. There will always be more space on the shelves in my library for Bill's next book.

Inevitably, like most collectors, I am asked the questions: 'When did you start collecting?' 'Why do you collect?' and, specifically in my case, 'Why *Normandie*?' Two of the three questions are easy to answer. I

started collecting in the early 1970s, when I was 12 years old. The 'why' can be summed up by my lifelong love of art and beautifully designed objects. And when you love something, you want it surrounding you.

And then 'Why *Normandie*?' which is a more complex answer. As a child I would voraciously read about ocean liners and marvel at pictures of their stunning interiors. For Christmas one year, my brother Peter gifted me a book about ships. It was titled *The Sway of the Grand Saloon*, by John Malcolm Brinnin. There were a few chapters and some of the photo section devoted to a ship I hadn't read much about before called *Normandie*. Well, what can I say except that a few paragraphs into those chapters I was hooked. I immediately knew this was the ship I wanted to read more about and that I had to have 'something' from. I thought then, as I do today, that *Normandie* is one of the (if not 'the') most beautiful ocean liners ever built.

As a designer myself, one of the periods of design that most interests me is art deco. And I believe the French did it best. After all, it started with them in Paris at the *Exposition des Arts Décoratifs* in 1925. Designers and artists such as Ruhlmann, Leleu, Lalique, Dupas and Dunand ruled supreme at that exhibit. Stunning interiors and artwork were on view, the likes of which the world had never seen before in their modernity and boldness. Art Deco was a clear and definitive break from the Art Nouveau style in vogue previously.

To say *Normandie* was a showcase of Art Deco is an understatement. I think a more apt description of the ship is it was the quintessential embodiment of French Art Deco design. The French clearly were not just building an ocean liner, but a ship of state that would showcase the engineering and design genius of France. In my opinion no ocean liner was so thoughtfully designed and cohesive as *Normandie*. A friend of mine in Paris sums up her interiors best: 'They flowed like the finest champagne.' Every public space and stateroom was a masterpiece of the designer and artisan commissioned for its execution. The materials were the best and most luxurious that existed, from Aubusson upholstery and carpeting, incised lacquer walls, Lalique glass lighting, to the *verre églomisé* murals. *Normandie* was the ship of superlatives, too: the longest and fastest liner; the most expensive liner ever built; the first with a designated and true theatre; the first with an air-conditioned dining salon; and the only liner (and I believe this fact still holds to the present day) where no two first-class suites or staterooms were repeated in design or colour scheme. Remarkable then, and remarkable today!

Daum, Christofle, Puiforcat, Ercuis, Lalique (both father and daughter), Haviland, Brandt and Luce all were commissioned to design silver, china

and glassware for the ship, all boldly and proudly emblazoned with the new CGT streamlined circular logo.

Over the last thirty-eight years since I started collecting, I've been very fortunate to have acquired some of her artwork and furnishings. And even though I've had many of these pieces for many years, I still look at their design and marvel at their quality and beauty. Most of the people who come into my home have no idea that the chair they are sitting on, the painting on the wall or ashtray on a table top is from *Normandie*. But more times than not, they do comment how beautiful the chair is or how stunning the painting is or about the great design of the ashtray. And if they are lucky enough, I'll wax rhapsodic about the item's provenance and designer.

I've stopped collecting in the past few years, however. I think it's time to just be content with what I have, and enjoy it for the rest of the time I'm 'curator' to it. Of course, it still all brings me endless joy, and whether it's in my possession or moves on, as some of it has in recent years, it will always be a big part of my life and memories. My involvement in the South Street Seaport Museum exhibit *DecoDence* was, in hindsight, maybe an unplanned swansong for my days of collecting *Normandie*. The exhibit was thrilling and personally rewarding to be a part of. I have Bill Miller and the kind people at the South Street Seaport Museum to thank for that opportunity.

DecoDence ran for fourteen months and had no less than two gala openings. Attendance was high and included many specially moderated group visits: budding designers and soon-to-be architects; French journalists and television crews; representatives from French firms in New York; members of the World Ship Society, Steamship Historical Society and Beaux Arts societies; the Marine Radio Operators Association and, rather expectedly, a special reception staged by the Art Deco Society of New York. There were also a few *Normandie* passengers, as well as several members of the salvage team and, of course, many passengers from the post-war French Line. 'It was like seeing holy objects,' said one visitor, who had travelled from San Francisco. 'I like art deco. I like ocean liners. But most of all, I like the *Normandie*, the finest ocean liner of all time.'

On a warm afternoon, in June 2010, a large crowd gathered. That steam whistle was again taken out of storage, brought to the Seaport Museum and sounded once again. This was the 75th anniversary of *Normandie*'s maiden arrival into New York Harbor. Afterwards, there was applause and cheers. Yes, *Normandie* was a legendary ship – and that legend lives on!

BIBLIOGRAPHY

Baul, Patrick, *Half Century of Cruise Ships in Saint-Nazaire* (Spezet: Coop Breizh Publications, 2003).

Braynard, Frank O. & Miller, William H., *Fifty Famous Liners*, Vol. 1 (Cambridge: Patrick Stephens Ltd, 1982).

Braynard, Frank O., *Picture History of the Normandie* (New York: Dover Publications Inc., 1987).

Harvey, Clive, *Normandie: Liner of Legend* (Stroud: Tempus Publishing Ltd, 2001).

Miller, William H., *Picture History of the French Line* (New York: Dover Publications Inc., 1997).